Maryland's Lower
SUSQUEHANNA
RIVER VALLEY

Maryland's Lower SUSQUEHANNA RIVER VALLEY

WHERE THE RIVER
MEETS THE BAY

DAVID A. BERRY

THE
History
PRESS

Published by The History Press
Charleston, SC 29403
www.historypress.net

First published 2009

Manufactured in the United States

ISBN 978.1.59629.653.4

Library of Congress Cataloging-in-Publication Data

Berry, David A. (David Allen), 1954-
Maryland's lower Susquehanna River Valley : where the river meets the bay / David A.
Berry.
p. cm.
Includes bibliographical references.
ISBN 978-1-59629-653-4
1. Susquehanna River Valley--History, Local. 2. Susquehanna River Valley--Social life
and customs. 3. Susquehanna State Park Region (Md.)--History. 4. Susquehanna State
Park Region (Md.)--Social life and customs. I. Title.
F187.S8B47 2009
974.8'49--dc22
2009015518

CONTENTS

PREFACE

You could ask the question "Why a write a history of the Lower Susquehanna River Valley?" There are a few obvious answers. There is a physical beauty that transcends the lack of major cities and notable landmarks. There were few famous people born in the region, but those who were have had a major impact on American culture. No one embodies the ethics of the region better than Havre de Grace native and Hall of Fame baseball player Cal Ripken Jr. No locals find his streak of continuous games unusual. That's what you do when you live in the Lower Susquehanna River Valley: you go to work each day. The area has also contributed at least one major American art form: carved duck decoys. The easiest answer of all is that my wife and I have chosen to live in the area and that you write about what you know, but this was a learning process for me. I learned how little you really know about your home territory. My knowledge is far more extensive now than before I began.

The first reason for the book is to fill a need. There are basically two types of local histories, three if you count the purely photographic essays. There are vertical histories that cover one subject over a number of years. *The History of the Maryland Legislature* is an example. There are horizontal histories such as *Maryland and the Civil War.* The subject is broad, but the time frame is limited. Some of these rely on family legends more than facts, while others are well researched, well written and a valuable source of information to future historians.

A complete history of Maryland could not exist in one volume. There is simply too much material. Maryland has a long and complex history, and what happened on the Eastern Shore is completely different than what occurred in the western mountains. It's best to break the subject into smaller, readable bites. This book is an attempt to write about the Lower

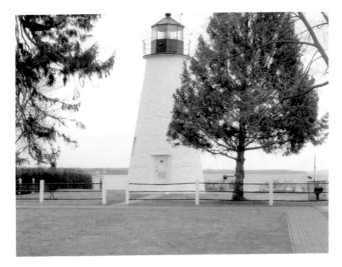

There is no stronger symbol of the Lower Susquehanna River Valley than the Concord Point Lighthouse in Havre de Grace. Built in 1826, it's the longest continuously working lighthouse in the United States. *Photo courtesy of the author.*

Susquehanna River Valley, vertically as well as horizontally. It is limited to one small region, but each essay covers one subject as completely as possible.

The second reason for the book is simple curiosity. My thought as a writer has always been that if I'm curious about a subject, other people must also be curious. I was very curious about this region. Other parts of Maryland are of less interest to me because so much has been written about them. The books, both fact and fiction, that romanticize Maryland's Eastern Shore would fill several shelves at the library.

One thing I suspected before starting the project is that the Lower Susquehanna River Valley has played a more important role in history than one would expect. This initial feeling proved to be correct. The region has had a role in many of the seminal events that later defined us as a people and a country. The river has been a driving factor over the years. People have used it, abused it or crossed it for centuries. It is no different today. The Susquehanna River and its opening to the larger Chesapeake Bay are the drawing cards.

There is one other reason I wanted to write this book—to try and project the reasons why an outsider such as myself has fallen in love with the area. I hope as a reader you come to appreciate the Lower Susquehanna River Valley as much as I do.

THE SUSQUEHANNA RIVER

I t's a typical October morning in northern Maryland. The air is cool, the sun is bright and the clear, blue skies promise a warmer afternoon. The trees in both Cecil County to the east and Harford County to the west are showing the first hints of color. It's a good day to be out on a boat. Twenty-two fourth-grade students from a local elementary school are sailing between the two shorelines on the skipjack *Martha Lewis*. They're here for a day of Chesapeake Bay studies and to discover more about the origins of the largest estuary in North America. They watch as one of the volunteer instructors raises a bucket of water onboard. The students will soon be conducting a turbidity test, looking for the amount of solids suspended in the water.

The captain of the *Martha Lewis* interrupts. He asks the students to look over the bow of the boat. He points to an old stone building on the Cecil County side. "If you draw an imaginary line across the water from that old building to the lighthouse you can see behind us," he says as he motions toward the Concord Point Lighthouse located on the Havre de Grace, or western, side of the water,

we are at the exact point where the Susquehanna River ends and the Chesapeake Bay begins. [He motions northward, or up the river.] The river, the Susquehanna, is the main source of fresh water for the Chesapeake Bay. Any place where two bodies of water meet becomes historically important. This spot, where the Susquehanna joins with North America's largest estuary, has been a witness to many of our country's most significant events. People have lived in this Lower Susquehanna Valley for almost twenty thousand years. It's seen Native American villages, early European explorers, and parts of the Revolutionary War were fought along its shores. A major battle of the War of 1812 was fought in 1813, and

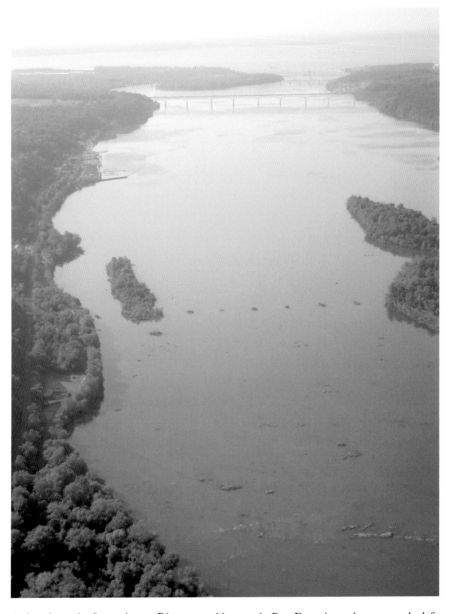

A view down the Susquehanna River toward its mouth. Port Deposit can be seen on the left shoreline. The first bridge is the Tydings/I-95. *Photo by Ben Longstaff, IAN Image Library, www.ian.umces.edu/imagelibrary.*

over there [he motions toward the Eastern Shore] *was a large camp for Union soldiers in the Civil War. It's been a logging capital, an abundant source of fish, the best place in America to hunt ducks and once home of the biggest horse racetrack in the U.S. We're only the most recent residents.*

The bucket of water comes over the rails of the *Martha Lewis*. Two drops spill on the deck. Tracing the path that these two single molecules of water have taken to reach the *Martha Lewis* is the first step toward understanding the history of the Lower Susquehanna River Valley.

The first drop began its journey six days and 448 miles north. Water flows gently out of the south end of Lake Otsego near Cooperstown, New York. Our drop, unnoticed by the millions of baseball fans who visit Cooperstown each year, joins with others to form a small stream that winds through the farms and valleys of rural New York State. A person could almost step across it for the first twenty miles. The flow increases as more water enters from hundreds of small side creeks. Approximately 165 miles south of Lake Otsego is Binghamton, New York. The Chenango River, the largest tributary so far, empties into the main stem here. This addition changes a meandering stream to a river. Our drop is part of the North Branch of the Susquehanna River.

The original meaning of the word "Susquehanna," like many names borrowed from the original natives, is under some dispute. The most popular explanation is that Captain John Smith, the first European to map and write down his experiences in exploring the Chesapeake Bay, named the river after the natives who greeted him as he sailed into the Lower Susquehanna Valley in 1608. He called them Sasquesahannoxcks or Sasquesahanougs. These multiple spellings were later formalized as Susquehannocks. The "hanna" suffix may be Algonquin for "stream," but later theories say that Susquehanna is a corruption of another word, "Queischgekhanne," meaning "long reach river." An even later version says that "Susqueh" means "mud." Long Muddy River would be an accurate description of the Susquehanna and would suggest that runoff is not a recent problem.

It's been called the Susquehanna River for four hundred years, and each day it passes Binghamton and continues to wind through parts of New York until it makes its final turn southeast into Pennsylvania. The Chemung River and Towanda Creek add more water as the Susquehanna twists and turns into the Wyoming Valley of northeastern Pennsylvania. It flows past the Pennsylvania cities of Scranton and Wilkes-Barre. Our first drop is 270 miles from Lake Otsego. The Lackawanna joins, and the character of the river

again changes. It's no longer a scenic byway. It's a working river. It has cut through layers and layers of rock for centuries, exposing various minerals, especially coal. That coal helped fuel the early development of the United States, but at the expense of the environment downstream.

The final Susquehanna is not one river, but two. The West Branch is the source of our second drop of water. The definitive beginning of the West Branch is more difficult to locate. Experts agree that it rises out of a pasture somewhere in either Cambria or Clearfield County, Pennsylvania, but local people just say that it begins in Carrolltown. Our second drop will travel its own winding path for 240 miles before it joins with its companions in the North Branch near Northumberland, Pennsylvania. It will pass through terrain remarkably different from the North Branch. It's wilder and more rugged. Coal and other minerals were mined along these shores, but here timber was the main industry and the scars from decades of clear-cutting are still visible. Millions of raw logs were sent southward in the mid-1800s, directed by as many as fifty thousand men at one time. Williamsport, Pennsylvania, just north of where the two branches of the Susquehanna join at Northumberland, built its economy on timber and became for a few short years one of the richest communities in the United States.

The combined West and North Branches turn southward for the final 123-mile journey. The Juniata River, the Susquehanna River's largest tributary, joins north of Harrisburg, Pennsylvania. The river passes several dams, the largest being the Conowingo, twelve miles upstream from where the schoolchildren are now raising the sails on the *Martha Lewis*. Our two drops have traveled the length of the longest nonnavigable river in North America. They are now a key ingredient in North America's largest estuary.

The exact dates for the origin of the Susquehanna River fall into one of two theories. The first is that the river appeared as the land mass rose above a shallow sea that covered the continent three hundred million years ago. The other view holds that sixty-five million years ago, one last violent upward thrust of land occurred in what is now upstate New York, creating elevation changes that allowed the sluggish water to begin a southward flow. The Susquehanna River Valley began to form as the now moving water ate into the bedrock.

Thirty-five million years ago, the downhill flow of water was helped considerably when a bolide, an extremely large meteor, slammed into the surface of the earth near modern-day Cape Charles, Virginia. The resulting crater was as large as Rhode Island and as deep as the Grand Canyon. It was immediately filled with the resulting rubble and was not discovered again

Where the River Meets the Bay

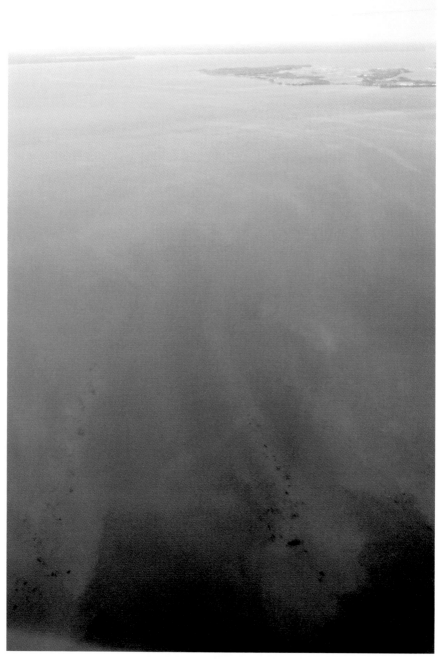

An aerial view of the Susquehanna Flats reveals the amount of turbidity in the water, as well as the shallowness of most of the Chesapeake Bay. *Photo by Jane Thomas, IAN Image Library, www.ian.umces.edu/imagelibrary.*

until 1983, but the result was the creation of a slight, southern-oriented slope. Water flowed more easily toward the Atlantic Ocean.

The Chesapeake Bay, in the simplest geological terms, is the result of a flooded Susquehanna River. Glaciers made three appearances in the area over several million years. Each succeeding layer has shaped the land as the melting waters escaped from behind the ice walls. This water, ejected at a force far stronger than any modern-day flood, created a natural, deep riverbed that runs the length of the modern Chesapeake Bay. Ten thousand years ago, the last wave of glaciers that covered Pennsylvania with mile-thick sheets of ice began its final melting. The current coasts of the Delmarva Peninsula would have been around 180 miles farther east than they are today. The Susquehanna River and Chesapeake Bay began their final emergence from under the ice. The escaping water carved additional rivers and streams, creating more tributaries. Low-lying areas created by previous glaciers were flooded. The current configuration of both the river and bay would have appeared three thousand years ago. We would recognize it. The original Susquehanna River bed, carved by the melting ice, lies beneath the surface and allows for the deep-water shipping channel on the Chesapeake Bay.

The Susquehanna River runs through five physiographic provinces created when the plates forming the earth's surface moved and collided. Ridges of mountains were forced upward. Deep valleys lie between these ridges. The river begins in the Appalachian Plateau Province and flows southward through the Appalachian Mountain Province, the Valley and Ridge Province and the Great Valley Province, home to the extremely fertile farm fields of Central Pennsylvania's Amish country. The Lower Susquehanna River Valley is located in the most southerly province, the Piedmont. The soil turns sandy and is poorer than the dark loam of the ground five miles farther north. The separation between these two lower zones is the Martic Line, the location of several major earthquakes, including one in 1984 that measured 4.1 on the Richter scale. Its epicenter was close to the Peach Bottom Nuclear Power Plant.

The Chesapeake Bay, more properly called an estuary, requires a constant mix of salt and fresh water. The Susquehanna, the sixteenth largest river in the United States, provides more than 90 percent of the fresh water needed in the upper Chesapeake Bay and more than 50 percent of the bay's total requirements. Twenty-five billion gallons of fresh water flow out of the Susquehanna River on an average day. That's enough water to supply the needs of every family in the United States and still have close to a billion gallons left over each day as a reserve.

That's on an average day, but the Lower Susquehanna River Valley is never the same. The river drains an area the size of South Carolina, about twenty-seven thousand square miles. As a result, it is one of the most flood-prone areas in the United States. A storm three hundred miles upstream, one during which Maryland sees no moisture, can send as much as 650 billion gallons roaring down the valley. There are years when as little as 2 billion gallons flow into the bay on a daily basis, creating huge environmental issues farther down the Chesapeake Bay.

There is no official point at which the Lower Susquehanna River Valley begins and ends. The fall line, a geomorphologic term for the location where an upper bedrock region meets a coastal plain, provides the best frame of reference. The fall line on the Susquehanna River, known since 1608 as Smyths fales or Smith Falls, is about eight miles above Havre de Grace, Maryland, and four miles south of the Pennsylvania state border. Captain John Smith's records and maps indicate that he did not travel farther north because of the difficulties of navigating the boulder-packed shallow water.

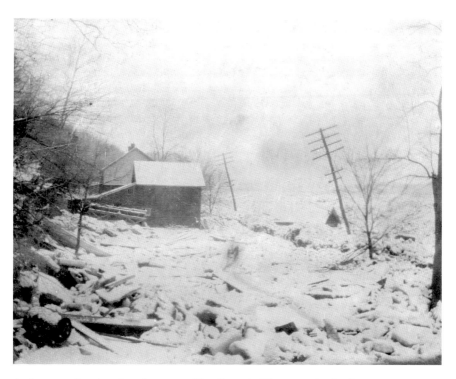

An ice gorge has risen into the town of Port Deposit. These massive ice floes were common every winter until the 1920s. *Photo courtesy of the Historical Society of Cecil County.*

The Conowingo Dam sits virtually on top of Smith Falls. This compact area fully encompasses three key towns—Havre de Grace, Perryville and Port Deposit—along with the shoreline of both Cecil and Harford Counties in Maryland. Historically important facilities such as the Bainbridge Naval Training Station, Perry Point Veterans Hospital and Susquehanna State Park are located inside this definition of the Lower Susquehanna River Valley. Garrett Island, once known as Palmer Island, is in the middle of the river. It's been uninhabited for many years, but it, too, has been a key player at various times.

It all comes back to the river. Since the first nomads wandered out from under the ice, people have looked to the river as a source of growth and prosperity. These dreams succeeded as often as they ended in frustration, but this constant struggle shaped many of the political and economic decisions of the United States. The result is that the Lower Susquehanna River Valley has a rich and varied history that tells a story far greater than one about three simple river towns. We start with two drops of water, but the story is about people building a life that continues to change even into the twenty-first century.

TRUE NATIVES

The construction of the Conowingo Dam created a mad scramble caused by an unlikely group of people: archaeologists. The task was to save a significant find that would disappear forever as the floodwaters created by the dam rose. At some point, an unidentified group of Native Americans had left a series of petroglyphs, or rock writings, in the steep cliff walls that formed the shoreline of the free-flowing Susquehanna River, evidence that those of European descent are far from the first people to settle in the Lower Susquehanna River Valley.

This abundance of natural resources left behind by the melting glaciers allowed the hunters to develop a slightly less nomadic existence. Their lives of constant movement were ending, increasingly replaced by one surrounding small villages. The Early Archaic period was beginning, and the first communities of the Lower Susquehanna Valley were growing. The natives of that era left behind no evidence of houses and cooking vessels, but a significant number of their crude quartz tools have been found, separating them from the preceding pure hunters. It's believed that the people of the Early Archaic period domesticated the dog.

The next period, lasting from around 4000 to 2000 BC, was the Late Archaic. These people continued to form communities, but ones that followed the best hunting or seasonal crop growth. Their tools improved, especially the spears used in hunting. Archaeological finds reveal that their diet consisted mainly of meat and fish but also of fruit, berries and grains.

The climate continued to stabilize, and the people of the Lower Susquehanna River Valley adapted with the change. The Transitional period, 2000 to 1000 BC, and the Early Woodland Period, 1000 to 500 BC, saw the introduction of gardens and cooking vessels. Life spans became longer as cooking food became more prevalent. They invented fish weirs

with which to catch fish and canoes for more efficient transportation. Houses appeared, as did the use of tobacco. There is evidence that goods were traded over long distances. Larger villages appeared between 500 BC and AD 500. Clay pottery, the bow and arrow and corn all were introduced in this Middle Woodland period.

The first Europeans who arrived in the 1500s entered in the Late Woodland period. The natives had a diet rich in fruits and vegetables, as well as fish and meat. They built towns with walls to protect themselves from neighbors, but at the same time, travel and trade increased. These were the people called the Susquehannocks by Captain John Smith. They lived along the Susquehanna northward into modern Pennsylvania. Their largest village was near today's town of Columbia in Lancaster County, Pennsylvania. To the east, along the Delaware River, were the Delaware Tribe, and the Massawomeks lived farther south beside the Bush and Gunpowder Rivers.

Each of these tribes claimed hunting privileges far into the others' territory, and bitter, bloody wars were fought to protect these rights. The Susquehannocks were particularly fierce, and as Iroquois, they frequently battled with the Piscataways of the Western Shore and the Algonquian-related Nanticokes of the Eastern Shore. What they could not imagine was the fact that their greatest and final battles would be fought with a people they first considered gods—the European settlers.

The earliest contacts between the Native Americans and the Europeans are poorly recorded. French trappers were probably common in the area for decades before widespread exploration began. The Italian explorer Giovanni de Verrazano landed on Maryland's Eastern Shore in 1524. He called it Arcadia in honor of its rustic beauty. He and his crew did come in contact with natives, who briefly came out of the woods. A year later, Pedro de Quexos, sailing the Atlantic Coast for potential harbors, noted the presence of a large bay to the north of Cape Hatteras, but he never sailed into it. Exploring the bay wasn't considered until 1570, when Captain Vincent Gonzales rescued the remains of a Jesuit mission in North Carolina. He conducted a survey sponsored by Pedro Menendez-Marques in 1588, sailing his ship, the *San Lucar*, and thirty men up the entire bay. This was the same year that the Spanish Armada attempted to invade England only to be defeated in one of the most famous naval battles in history. The Spanish were not interested in further settlements. The Chesapeake Bay was left to the English.

The Susquehannocks were initially friendly toward settlers, perhaps not realizing that the Europeans intended to stay. They worked as fur trappers and guides while continuing to wage war on their neighbors. That warlike

attitude was occasionally turned toward the ever-growing population of settlers. The unpredictable situation upset the Europeans to the point that the rulers of the Maryland colony were determined to bring the natives in line. Kent Island passed a law that decreed that none of the estimated population of three thousand Susquehannocks could visit the island without prior notice, a restriction that the natives ignored. The settlers decided to enforce the regulation by constructing a fort on Spesutie Island in 1650. Manned by a force under Nathanial Utie, the fort's location at the mouth of the Susquehanna River effectively prevented easy access to points farther south. (Utie was a handy man to have around. He used the same location to defeat the Dutch pirates that had been terrorizing the English settlements around the Chesapeake Bay.)

The problem of how to deal with the natives was discussed as early as 1609. Robert Gray, writing about the Virginia settlements that year, asked, "By what right of warrant can we enter into Indian land and take away their rightful inheritance from them and plant ourselves in their places[?]" Gray may have been reflecting on the complexity of the situation, but the English wanted the land that the natives were on. The solution was to simply resort to racial stereotyping. It is easier to seize land from an ignorant savage than a peer. The English believed, or at least convinced themselves, that the natives held the land but lacked the knowledge to exploit it properly. The best solution was a sort of cultural exchange. The English would introduce Christianity to the natives, who would then be so grateful that they would share the land with the settlers. The tribes resisted the terms of the exchange; they wanted no part of English culture and only wished to be left alone on the land on which they had lived for hundreds of years.

The result was the annihilation of the Susquehannocks. Leonard Calvert, Maryland's first governor, continued to pressure the tribes as increasing numbers of settlers moved into the Lower Susquehanna Valley. The natives themselves made a tactical mistake in 1661 when they engaged in a long, fierce war with the Cayugas and Senecas. They fought for twelve years and were close to victory when a smallpox epidemic ravaged their villages, reducing their total population to three hundred people by 1673. The Senecas, recognizing a weakness, drove them from their homes. They were finally allowed to return to the Lower Susquehanna Valley when they formally surrendered to the Senecas. They managed to live in peace for another hundred years until a series of attacks on white communities turned settlers against all Indians. The twenty survivors of the Susquehannocks, mostly old men, women and children who had converted to the Quaker faith, were murdered in 1763 by an angry mob of settlers known as Paxton's

Boys. The natives were hiding in a Lancaster County, Pennsylvania jail and had been living peaceful lives working as artisans.

After thousands of years, the natives of the Lower Susquehanna River Valley had been eliminated by 150 years of contact with the Europeans. The land was finally available for the next phase: permanent European settlements.

CAPTAIN JOHN SMITH

There would be no contest if we were forced to choose the one individual who made the maximum impact on the Lower Susquehanna River Valley over the past four hundred years. One historian, Edward Wright Haile, has gone so far as to say that if George Washington is the father of our country then this man would be the grandfather. Haile can make this claim without fear of hyperbole. Captain John Smith, reluctantly chosen as one of the leaders of Jamestown, proved his value in many ways, not the least by teaching the poorly prepared settlers basic survival skills, but Smith's ultimate contribution was that he appeared at the exact moment history needed him.

The Chesapeake Bay lacked an advocate, someone who could speak with authority about it because he'd been there. The Virginia Company, the English land company that sponsored the development of Jamestown, needed good publicity. The only reports it had received so far were stories of hostile natives, rampant disease and the settlers' ability to die in record numbers. Smith proved to be a first-class advocate. He did what great men have always done. He went out and looked for himself. Smith's efforts changed people's perceptions. It was not just some wild and uncontrollable wilderness but a place where the right men, working hard, could experience a future of unlimited potential.

Europe in the late 1500s was in a constant state of turmoil. Power shifted between the Dutch, the Spanish, the French and the English. Wars were fought, each country hoping to come out slightly ahead of its rivals. Their economies, weakened by constant war and growing populations, depended on expansion. They needed land, gold, silver and the prospect of new trading routes and partners.

The English Queen, Elizabeth I, died in 1603, an event that placed her nephew, James I, on the throne. The stockholders of the Virginia Company proposed sending three ships, the *Susan Constant*, the *Godspeed* and *Discovery*, with 140 men to establish a colony along the James River. James gave them his royal approval, and the result was a circuitous five-month journey under the command of Christopher Newport that ended at Cape Henry at the mouth of the Chesapeake Bay on April 26, 1607. The colonists soon moved up the James River to a more permanent location.

The Virginia Company had sent sealed orders to be opened upon arrival that would establish the chains of command and organization. Newport and the other noblemen were surprised to find that the home office had selected Captain John Smith to be one of the colony's key leaders, a troublesome directive since they had locked Smith up during the long voyage, expecting to execute him at their first landfall based on trumped-up charges of plotting insurrections. His worse sin, they felt, was that he was a commoner. Wiser men saw that Smith was much more valuable alive than dead. Despite an unpopular tendency of speaking his mind, he knew more about leadership in hostile conditions than any of his fellow settlers.

Smith was born in Lincolnshire, England, in 1580. His father forced him to begin a short-lived career as a teenaged apprentice to a local merchant, but the always restless Smith quickly volunteered as a soldier of fortune, seeing action in Hungary, France, the Netherlands, Romania and Morocco. He was both a slave and a prisoner of war in Russia and Turkey, escaping from both to return to England.

He emerged from these adventures as a competent soldier equipped with a deep intelligence, a high energy level and two characteristics often absent in his contemporaries: common sense and a will to survive. He felt that his role at Jamestown had two purposes—help the colony grow and carry out the orders of the Virginia Company. It wanted a thorough search for potential riches and had sent a small, dissembled boat called a shallop to aid in the effort. Smith intended to complete the assignment as soon as he dealt with a few local problems, the major one being that the previously friendly natives had become increasingly aggressive and had turned to kidnapping the colonists, including Smith himself. It was December 1607 before he could prepare the shallop and its crew for exploring.

Smith, despite his strengths, also suffered from a strong need for self-promotion. He never failed to stretch the truth to make himself appear the hero if it could be done safely. The exceptions to these antics were his three voyages of exploration, covering more than three thousand miles

and the entire length of the Chesapeake Bay. He felt that these efforts were being conducted as a result of a direct order from his commanders back in England. Smith would not violate that trust.

The crew varied slightly among the three trips, but Smith organized a cross section of the Jamestown colony including a doctor, six gentlemen, seven soldiers, a fishmonger, a blacksmith, a tailor—whose sewing skills would soon be needed on shallop's sails—and a carpenter. Smith choose them not because of their status in society but because they had the skills and temperaments to undertake such a dangerous journey.

Their first exploration would last two months. Smith and his crew mapped the upper reaches of the James River during the months of December 1607 and January 1608. These initial efforts helped him test his vessel and his crew, as well as allowing him to set his standards for mapmaking and writing journals.

Smith's next two voyages began in early June 1608. He reached as far north as today's Gunpowder River and up to the Great Falls of the Potomac, located a few miles above modern Washington, D.C. He was also stung in his arm by a stingray near what is still called Stingray Point. Smith apparently believed that he was dying and directed his crew to dig a grave. His recovery, like many of Smith's adventures, proved to be miraculous, and the next day they were back underway.

They set out again from Jamestown on July 24, 1608, and this time reached as far north as modern-day Port Deposit. The spot is still called Smith Falls. Historians believe that they camped on Garrett Island near the mouth of the Susquehanna River. They were greeted by sixty Susquehannock Indians, a people described by Smith as giants, though the average height was probably around five feet, eleven inches, not quite giant by today's standards, but men who would tower over a seventeenth-century Englishman. Smith took quick advantage of the natives' peaceful approach and named the river for them.

Europeans had arrived in the Lower Susquehanna River Valley. We can imagine Captain John Smith resting on Garrett Island on a hot, humid Chesapeake Bay night and considering what his explorations had discovered. He was experienced and astute enough to realize that the dreams of the Virginia Company back in England were unrealistic. They would not find gold or silver. There would be no passageway to the northwest, but Smith knew that he had found something far more valuable. He had found the resources necessary for a hardworking people to build a life. The waters of the Susquehanna River flowed around the island,

just one of many streams that Smith had mapped. These rivers would be a source of transportation, and each year their floodwaters would leave behind rich agricultural soil. There were stands of timbers, wildlife and seafood in such abundance that no one could imagine that they would ever be depleted. He had found what he described in his *True Relation of Occurrences and Accidents in Virginia*, published in 1612: "Heaven and Earth never agreed to frame a better place for man's habitation."

Smith would be forced back to England in 1609 and would never see his "faire Bay" again. Jamestown would continue to suffer from hostile natives and foolish behavior for the next twenty years, but a foothold was finally secured. Garrett Island, where we can imagine Smith and his crew reflecting on their heroic efforts in 1608, would have a trading post and small settlements on it by 1621. Captain John Smith had started the inevitable march toward economic independence within the Lower Susquehanna River Valley.

FIRST SETTLEMENTS

Summer days in the Lower Susquehanna River Valley bring out the boaters. There are sailors, powerboaters, people fishing and those paddling kayaks. One of the favorite trips for the kayakers is to circumnavigate Garrett Island, the same island on which John Smith spent a night four hundred years ago. The 198-acre island has been owned for the last several years by the U.S. Fish and Wildlife Service and is protected as a wildlife sanctuary. It is home to hundreds of waterfowl and is an important spawning ground for shad and striped bass. Kayakers make their way around the island. Great blue herons and bald eagles watch from the shore. It's hard to believe that the island remains this pristine after almost four hundred years of European occupation. There is no visible evidence of buildings or other man-made objects. Even though Garrett Island may be officially off-limits to human visitors today, it was the first true settlement in the Lower Susquehanna River Valley.

John Smith and his fellow explorers were not the first to make use of Garrett's favorable location. Various archaeological projects conducted over the years show that the island—first called Watson's, then Palmer and now Garrett—was a common campground for succeeding generations of Native Americans. Various tools used both domestically and in hunting have been found, indicating that the early hunters used Palmer Island as a temporary village. They may have made use of the island's fertile soil to grow seasonal crops such as corn.

Fourteen years after John Smith's 1608 exploration, a grant was issued by the Virginia Company to Edward Palmer from Warwickshire, England. His plan was to prepare Watson's Island as a site for a great university, to be called "Academe Virginiensis et Oxoniensis." Watson's Island (the origin of

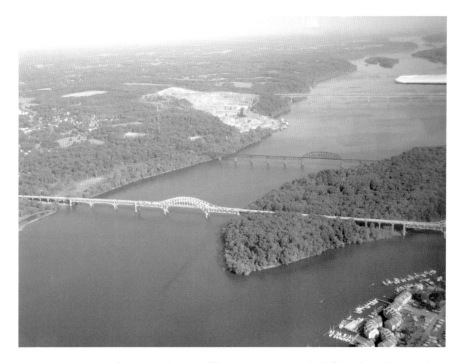

An aerial view taken farther up the river. The large quarry on the left has been in operation since 1905. Garrett Island and Perryville can clearly be seen in the lower right along with the Hatem/Route 40 Bridge, the CSX Railroad Bridge and the Tydings/I-95 Bridge in the distance. *Photo by Ben Longstaff, IAN Image Library, www.ian.umces.edu/imagelibrary.*

that name is unknown) was quickly renamed Palmer Island and became the first settlement in the Lower Susquehanna River Valley. To support his vision, Palmer and his followers, said to number more than one hundred men, joined in the rapidly growing fur-trading business.

Furs were in great demand across northern Europe, with the wealthy needing a constant supply in order to keep ahead of the latest fashions. The fur supplies in Europe had been seriously depleted, and when Henry Hudson announced that he had discovered a land with a seemingly endless number of furs, the rush was on. Hudson's Dutch West India Company competed with the Virginia Company to be the chief supplier of furs to the Old World, with each competitor using various Native American tribes as suppliers. The Dutch favored the Delawares, and the English the Susquehannocks.

Edward Palmer died in 1635, his dream of a great "publick" academy unfulfilled as a result of the impractical nature of the entire venture. No academic group wanted to homestead in such a remote area. His followers had no means of reaching a suitable market for their furs, and he trusted the

settlement's finances to a less-than-honest part of his team. Soon there was no money to pay the Virginia Company. The settlers returned to Jamestown, and Palmer Island was once again uninhabited until the appearance of William Claiborne, a man who would soon prove to be a thorn in the side of many other Maryland settlers.

Claiborne was a businessman and adventurer from the Virginia Company who first established a base on modern-day Kent Island. His efforts at developing more and more sources of furs led him to the now abandoned Palmer Island in 1631, where he established a second, and even more active, settlement. The island soon became the fur-trading center for the English working the Chesapeake Bay region.

Cyprian Thorowgood, the sheriff of St. Mary's County, visited Palmer Island and wrote about the trade between Claiborne and the Susquehannocks:

> *By this island boats use to ride being in trade with the Susquehannocks. Here we found a boat of Claiborne's in trade with the Indians, which had gotten 700 skins and 40 men laden with beaver were sent a little afore to the Dutch plantation, but as soon as they see us a coming, Claiborne's men persuaded the Indians to take part with them against us, if we did happily offer to take their boat, but the Indians refused saying the English had never harmed them, neither would they fight so close to home.*

Events were not standing still back in England. George Calvert, the first Lord Baltimore, applied to Charles I for a royal charter to establish the Province of Maryland. George died before the charter was granted, but his son, Cecil, accepted it in June 1632. His brother, Leonard, left for the colony in 1633, establishing St. Mary's City near the mouth of the Potomac as the first permanent settlement.

One of the first issues that Calvert's official settlers had to deal with was William Claiborne. He was the agent for the London Mercantile Company, a relationship that was becoming strained. Claiborne found that supplies were not arriving, and the Londoners were finding that Claiborne's fur shipments were falling short of expectations. As a result, Claiborne began pestering the boats sent out from St. Mary's City. Calvert seized the Kent Island trading post in 1635, forcing Claiborne to consolidate on Palmer Island. Claiborne claimed that the Susquehannocks had deeded it to him by treaty, providing him temporary relief, but his hold in the upper bay proved to be short-lived. A year later, the British Committee of Trade and Plantations ruled in favor of Lord Baltimore. Maryland would be his colony.

Claiborne was forced to flee to Virginia and later England. Calvert's people arrived at Palmer Island and found a settlement with more heads of cattle than people.

The supply of furs was decreasing and along with it the patience of the European settlers with the Native American threats. Lord Baltimore built a full-fledged fort, called "Conquest," on Palmer Island in 1643 as a stronghold against the increasingly aggressive Susquehannocks. It was well stocked with an ample supply of shot and powder, along with a house and windmill for grinding corn.

William Claiborne used the chaos of the English civil war and the execution of Charles I to make another appearance in the Lower Susquehanna River Valley. He reclaimed Palmer Island in 1652 through another supposed treaty with the Susquehannocks, believing that Oliver Cromwell, the English Parliamentarian who ruled England after the fall of the king, would rule against the Calverts. Claiborne lost all control when Cromwell returned Calvert to power in 1653. The Maryland governor declared that Claiborne's life and property could be taken at the governor's pleasure. Claiborne went back to England in hopes of changing Cromwell's decision but lost the appeal. His Maryland claims were seized by the state, and he retired to his Virginia estate. He enjoyed a brief period of political power, but he was again out of favor with the English rulers when he died in 1666.

Palmer Island was deserted when Cecil County was separated from the larger Baltimore County in 1674. The threat of marauding Indians was disappearing, and settlers had moved inland, establishing towns such as Charlestown and Head of the Elk. The early versions of Perryville, Port Deposit and Havre de Grace appeared along the shores of the Susquehanna. There were periodic attempts to establish communities on the island over the years, but it was primarily used for the storage of ice cut out of the frozen river; farming; and as a landing place for the growing fishing industry. Fish packinghouses were built on the north end of the island, but the workers commuted from the mainland.

The possibility of any future settlements was eliminated in 1885 when the B&O Railroad purchased the island in order to place two supports for its new bridge across the river. The railroad also renamed the island Garrett, after the president of the B&O, John W. Garrett. There were several attempts to develop Garrett Island in the twentieth century, including an aggressive plan in the 1990s to build a hotel and amusement park. The Conservation Fund purchased the island in 2004 and gave it to the U.S. Fish and Wildlife Service as one in a series of Chesapeake Bay–managed

wildlife refuges. Today, most visitors are kayakers who paddle the shorelines in search of waterfowl.

The restrictions that the railroad and the Wildlife Service have introduced will not prevent Garrett Island from suffering the same problem that has eliminated other Chesapeake Bay islands: natural erosion. Some day the waters of the Susquehanna River will wash away the last of the island, erasing an important part of our history, but until then Garrett Island will be remembered as the first settlement in the Lower Susquehanna River Valley.

BEAUTIFUL HARBOR

Palmer Island was not the only island used by the first settlers. Poole's Island, fifteen miles south of the mouth of the Susquehanna, and Spesutie, just five miles down the bay, had early settlements, but it soon became obvious that while living on an island presented many opportunities—such as access to transportation and security—there were an equal number of limitations. People began searching the mainland shorelines for suitable property on which to build a town. Harmer's Town was created on a flat stretch of land running along the western shore of the Susquehanna River.

The Harmer's Town of the seventeenth century has evolved into the Havre de Grace of the twenty-first century. Today it's a city of ten thousand full-time residents, along with dozens more who summer in the town's waterfront condos or in homes surrounding the Bulle Rock Golf Course. It has become a prime tourist destination, with five museums, a restored downtown area, summer concerts in the parks and the mile-long promenade used for strolling the waterfront. There are opportunities for sailing and kayaking, a half dozen bed-and-breakfasts and a dozen top-flight restaurants. It has come a long way from the two hundred acres awarded to Godfrey Harmer by the Lord Proprietor of Maryland in 1658, but it has not always been an easy trip.

Captain John Smith noted the beauty of this site during his first explorations of the Chesapeake Bay in 1608. Since then, Havre de Grace has been a fur-trading post, a potential capital of the United States, a site of a major battle by an invading force, a logging center, a railroad town, the duck and goose hunting capital of the country, the location of a major horse track and now a booming tourist, golfing and boating destination. The town's strength has always been its location where the Susquehanna River meets the top of the Chesapeake Bay. Since the first settlers arrived, entrepreneurs have

Where the River Meets the Bay

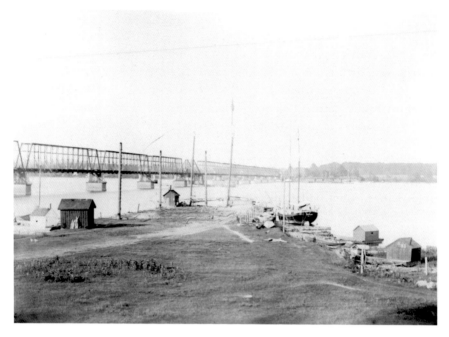

An image of the waterfront of Havre de Grace, taken in the late 1800s. The bridge shown is the first railroad bridge built, which later became the first bridge for automobile traffic. *Photo courtesy of the Historical Society of Harford County, Inc.*

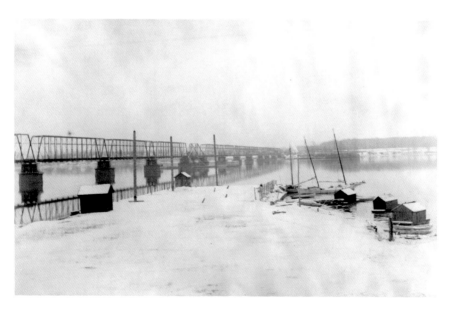

The same view taken in winter. You can see parts of Perryville across the river. *Photo courtesy of the Historical Society of Harford County, Inc.*

tried to connect the river with shipping on the bay. Havre de Grace was the logical starting point for each of the attempts. Generations of residents helped build the locks and towpaths, railroads, bridges and, finally, dams. In between projects they trapped logs that had escaped from the booms upriver in Pennsylvania, farmed, stretched nets across the river's mouth to catch massive numbers of fish and ran ferry services between their shores and those of Cecil County.

Harmer's Town measured 100 perches in depth and 320 perches in length. A perche, an antiquated unit of measurement even in pre-colonial times, varied from ten to almost twenty-seven feet, but records indicated that the original Harmer deed covered a section that ran from Concord Point at the southern end to the current location of the Amtrak Railroad Bridge at the northern one, a point opposite the southern edge of Palmer Island. Most of modern downtown Havre de Grace would have been included.

Regardless of its size, the property did not remain in Harmer's hands for long. It was reassigned to Captain Thomas Stockett in 1659 and was quickly renamed Stockett's Town. Captain Stockett and his family should be given credit as the founders of the community. During the thirty years of their ownership, Stockett's Town grew from a remote outpost to a small center

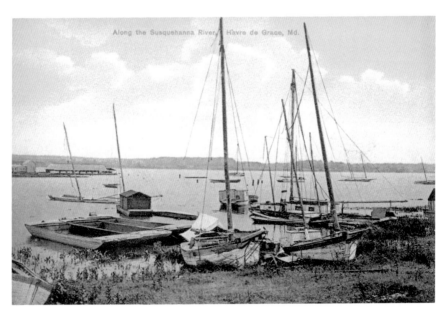

Another view of Havre de Grace's waterfront. Skipjacks and bugeyes are pulled onshore and anchored in the river. *Photo courtesy of the Historical Society of Harford County, Inc.*

of commerce. The Stockett family sold the property to a Dutch fur trader, Jacob Looten of Cecil County in 1688. The deed again specified a piece of land running from Point Conquest (as early maps call Concord Point) northward to a point opposite the southern tip of Palmer Island.

As the population grew on both sides of the river, so did the need for a satisfactory ferry service. William York and Jacob Young received permission from the General Assembly to establish the first commercial ferry in 1695. By 1700, the town became known as Lower Susquehanna Ferry, a name that was to stay in place for the next 80 years. The ferry remained in operation for 170 years. Town ownership did change hands again in 1714, when it was purchased by John Stokes, but by 1773, the year that Harford County was separated from Baltimore County, most of the lots in town were privately owned. A census in that decade put the population at two hundred people. The street configuration was laid out by Robert Young Stokes in 1782.

A hurricane is seldom good news, but the one that hit the Lower Susquehanna River Valley in 1786 had enough force to radically change the depths of the river at Havre de Grace. It created a harbor that averages twenty feet in depth and extends southward from Garrett Island. The only shallow area is off Perry Point, along the Eastern Shore. The Western Shore,

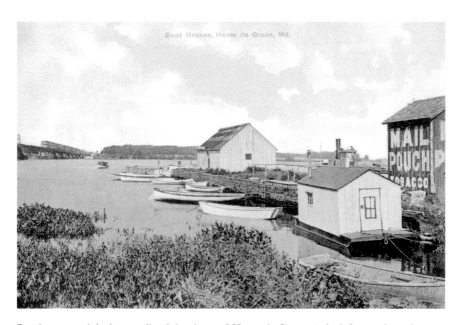

Boathouses and docks once lined the shore of Havre de Grace. A dock for seaplanes has been built about where this image was taken. *Photo courtesy of the Historical Society of Harford County, Inc.*

where Havre de Grace sits, was left with depths sufficient to accommodate larger cargo vessels. Port Deposit, five miles farther up the river, was the only other deep-water port in the valley.

There is a certain amount of speculation concerning how Lower Susquehanna Ferry became Havre de Grace. The most accepted story is that the French army officer Lafayette, who assisted the American forces during the Revolutionary War, passed through the region with 1,200 men in 1781, crossing the Susquehanna using Bald Fry's Ferry near the Pennsylvania border. He returned to this country for a visit in 1783. The trip from Mount Vernon to Philadelphia brought him into view of the town, which he said reminded him of Le Havre in France. He exclaimed, "C'est Le Havre." The expression stuck, and the town has been Havre de Grace since 1785. Some historians claim the story is legend and the dates don't always match up, but there has never been a more plausible explanation put forth as to why the name was chosen.

The growing community would suffer a major setback during the War of 1812 when the British fleet anchored off the town. Their cannons fired shells and rockets until there was only a handful of houses and one church left standing. Havre de Grace was rebuilt but went into a decline that lasted until the building of the Susquehanna and Tidewater Canal in 1839. The canal ran the forty miles between Wrightsville Pennsylvania and Havre de Grace, creating a direct competitor to the Susquehanna Canal that terminated across the river in Port Deposit. Havre de Grace experienced an economic boom for the next twenty years as trade goods poured down the river from the north.

The canals were doomed by the coming of the railroad, but their arrival continued Havre de Grace's prosperity. The northbound Baltimore and Port Deposit Railroad Company chose to terminate in Havre de Grace. The line opened in July 1837. It was connected by ferry to the southbound Wilmington and Susquehanna Railroad that stopped in Perryville. The ferry was used to haul rail cars between the two towns but was eliminated in 1866 with the opening of the first railroad bridge. Trains could now travel from Philadelphia to Baltimore without unnecessary stops.

The railroads brought industry to Havre de Grace. Lumber and fish dominated the local economy. Enterprising fishermen stretched nets across the mile-wide river, catching thousands of fish at a time. The harvest was packed in plants and canneries along the shoreline and then shipped by rail car. Millions of board feet lumber was being sent down the river from the upper reaches of Pennsylvania. Most of the logs were trapped farther north, but some escaped and floated into Havre de Grace. John DuBois, a

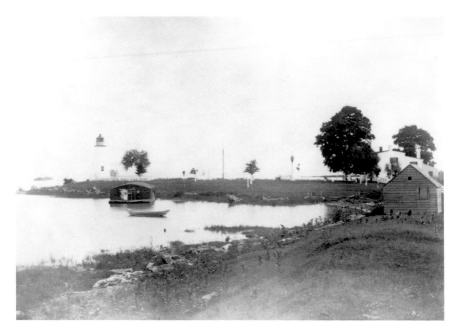

The Concord Point Lighthouse with the light keeper's house to the right. This photo was taken before most of the area was filled in to eliminate the wetlands. *Photo courtesy of the Historical Society of Harford County, Inc.*

Pennsylvania lumber baron, built a retention pond and sawmill in Havre de Grace that captured and processed the logs that got away from the booms upriver. Log Pond Marina was built on the site in the 1980s. Virgin logs were found on the bottom during construction. Many had been there for more than one hundred years.

Havre de Grace went through a downturn in the late nineteenth century. The canals were closing and railroads were finding that it was not financially viable to stop there. In the early twentieth century, though, wealthy visitors from nearby Baltimore, Philadelphia and Wilmington wanted to travel to Havre de Grace to fish, hunt ducks and bet on the horse racing at the Graw, once one of the most famous tracks in the country. The Bayou Hotel, still standing at the south end of town, was a luxury hotel built to accommodate the visitors. It featured one of the earliest indoor swimming pools. By 1950, the fish and duck population had declined, the Graw was closed as gambling came under increased public scrutiny and the Bayou went bankrupt.

Havre de Grace was forgotten for another thirty years, until pleasure boaters and amateur anglers began returning. Tidewater Marina, Havre de Grace Marina, the town docks in Tydings Park and the now defunct

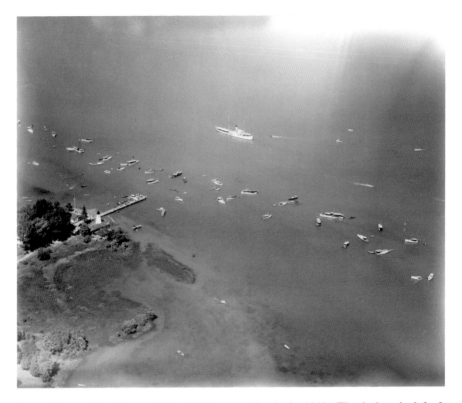

An aerial view of the Concord Point Lighthouse, taken in the 1940s. The dock to the left of the lighthouse was the Havre de Grace Yacht Club. The Promenade has been built along the shoreline to the right of the lighthouse. *Photo courtesy of the Historical Society of Harford County, Inc.*

Penn's Beach Marina provided easy access to the rest of the Chesapeake Bay. People found that the combination of waterfront living at low prices and a close commute to larger cities made it attractive for weekend homes, but it was also a place to live full time. The first waterfront condominiums, Log Pond and Canvasback Cove, were constructed in 1989 and drew people who wanted inexpensive water views with a place for their boat. Seneca Point, another complex near the center of town, was soon added.

A new marina, on the site of the old Penn's Beach, was finished in 2004. Three high-rise condominiums, called Heron Harbor, have been built on the same property. Construction has already begun on 2,800 single-family homes and town houses along the fairways of the world-class Bulle Rock Golf Club. Tentative plans have been announced to add additional condominiums with boat slips on a site along the Susquehanna River, north of downtown.

Where the River Meets the Bay

There's renewed interest in the old Victorian homes that line Havre de Grace's streets. Originally built during previous boom times, many have been converted to commercial offices, but an increasing number are being restored for single-family use. When the old property cannot be saved, it's razed, and new, high-end homes and duplexes are built. Real estate values were rising rapidly until the economic slowdown in 2008. The *Baltimore Sun* reported in its Sunday, March 20, 2005 edition that between 1999 and 2004, real estate appreciated at 54 percent in Harford County and over 70 percent in the Havre de Grace zip code. Havre de Grace changed from one of the poorest communities in Maryland in 1990 to one with an exceptional economic future.

The factors that made the town attractive in the past—the waterfront, the fishing and the sailing—are still in place, but there are now more reasons to visit. A few years ago, finding a good meal meant leaving town, but today people are drawn to Havre de Grace's restaurants. As of this writing, three new ones opened downtown in the past year alone. With higher-income families moving into the area to take advantage of the real estate values,

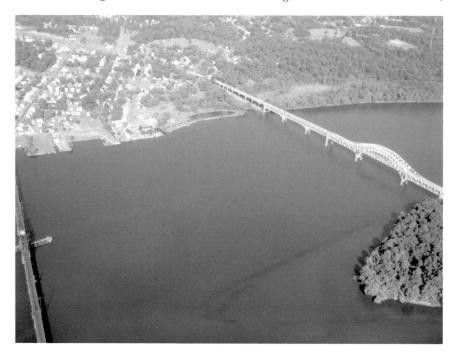

This is the north side of Havre de Grace. The Hatem Bridge for Route 40 is on the right, using the tip of Garrett Island as support, and the 1907 railroad bridge, now used by Amtrak, is on the left. The Lockhouse Museum is straight ahead. *Photo by Ben Longstaff, IAN Image Library, www.ian.umces.edu/imagelibrary.*

bagel shops and gourmet groceries cannot be far behind. The Promenade, destroyed in September 2003 by Hurricane Isabel, reopened on the first anniversary of the storm and runs along the water from the historic Concord Point Lighthouse to the town park. Tydings Park has weekly concerts in the summer, as well as the annual seafood festival in August. There are five museums with another proposed to honor the town's horse racing history. The Duck Decoy Festival in early May brings in thousands of wildlife art fans. Havre de Grace is the home port of one the last working skipjacks, the *Martha Lewis*.

The water remains the dominant feature. *Reader's Digest* named Havre de Grace the best place in the country for largemouth bass fishing. Shad and rockfish populations have been increasing. The sailing conditions are some of the most consistent on the bay due to the prevailing southerly breezes in the summer that funnel into the hills surrounding the mouth of the Susquehanna.

The most significant factor in the future of Havre de Grace is the expansion of the staff at the nearby U.S. Army weapons testing center, Aberdeen Proving Ground. At least ten thousand new jobs are expected to be in place by 2010, with each position bringing two additional people into the area and with Havre de Grace the logical place for people to live. Thomas Jefferson believed that the town named by Lafayette would become the major metropolis between Baltimore and Philadelphia. It has fallen short of that lofty prediction, but it is going through a renaissance unlike any other in its history. Harmer's Town has arrived.

BOOMTOWN

No town in the Lower Susquehanna River Valley has benefited, or suffered, more from its location than Port Deposit. It was the last navigable port for ships coming north. Barges came south with loads of lumber, whiskey, produce and flour. Chrome was brought overland from northern Cecil County in wagons. These shipments were met in Port Deposit by Chesapeake Bay ships that transported the material to Baltimore and Norfolk. By 1860, it was the eighth largest city in Maryland with a population of 2,000. It could boast of seventy-four places of business, the only bank between Wilmington and Baltimore, three doctors and no lawyers. The population in 2007 was 676 people, having fallen victim to economics because of its location. Railroads replaced the river and canals as the main method of shipping. Southbound railroads made the decision to pass through Perryville, five miles farther downriver from Port Deposit, because they could easily connect to northbound lines that terminated in Havre de Grace. The builders of America's highways would later make the same choice.

The location of the town is probably the farthest north Captain John Smith reached in 1608. The first historical reference was in 1729, when a ferry operated by Thomas Cresap, called Smith's Ferry, was opened for business. It terminated in the Harford County town of Lapidum. It was also referred to as the Upper Ferry or, on the Western Shore, Bell's Ferry. The ferry was taken over a few years later by Colonel John Creswell and renamed Creswell's Ferry. The three hundred acres of land that would encompass the future Port Deposit were originally patented to John Rycroft and called Mycroft's Choice or Widow's Lot. Creswell eventually came into posession of the property.

The Maryland legislature authorized the creation of a bridge company in 1808. Its goal was to construct the first bridge across the Susquehanna

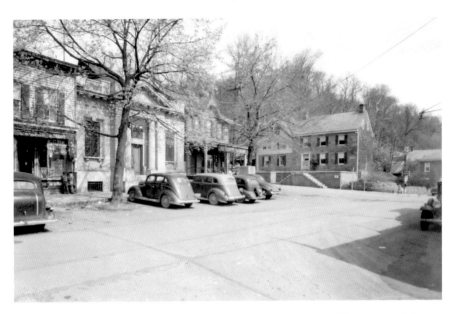

The main square of Port Deposit is shown in a photo dating to 1922. *Photo courtesy of the Historical Society of Cecil County.*

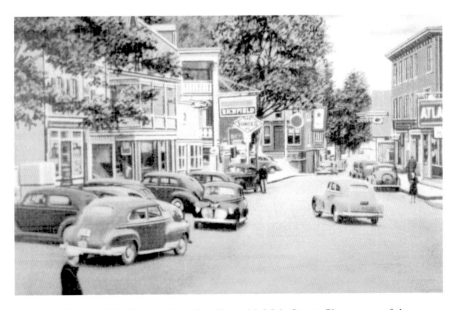

An undated postcard looking south on Port Deposit's Main Street. *Photo courtesy of the Historical Society of Cecil County.*

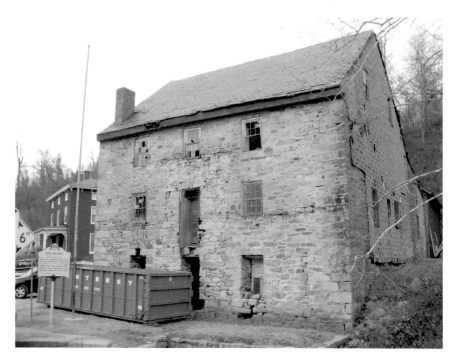

The Rock Run Mill in Port Deposit. It was opened in 1725. The original ferry was located about one half mile south. *Photo courtesy of the author.*

River near the site of the Creswell Ferry. A land survey was conducted in 1812 to look for a suitable spot for the eastern end of the proposed span. The document contains the first written reference to Port Deposit. The name had been changed in December 1812 by Governor Levin Wilder and the Maryland legislature. They felt that the many names of the town were confusing (it was also known as Rock Run). The governor said the name was an obvious choice because it was already a "port for lumber."

Phillip Thomas, who owned much of the land where Perryville and the Perry Point Veteran's Hospital are located, saw the potential in the Creswell's Ferry location. He had a surveyor lay out a town in 1812, but a year later, in the British invasion during the War of 1812, it was still so irrelevant that the British crossed the river to burn a warehouse, ignoring the few buildings in Port Deposit.

The population in 1819 had grown to two hundred people, but Port Deposit would soon enter its boom years. The Port Deposit Bridge, a wooden structure that used several of the river's islands in the design, first opened in 1818. It burned down in 1823 but was rebuilt and reopened in 1829.

The structure remained in service until 1854, when a herd of cattle broke through the planking. An 1857 storm washed the remainder downstream.

The bridged opened up the town for growth, but nothing had as much impact as the building of the canal. The Maryland legislature had incorporated the Susquehanna Canal Company in 1783 with a charter to build a thirty-foot-wide, three-foot-deep canal from Love Island near the Pennsylvania border to the fall line at Port Deposit. The goal was to finish it in seven years, but the Maryland Canal did not formally open until 1805. (The Maryland Canal and the Susquehanna Canal are one and the same.) The growth and success of Port Deposit can be directly attributed to the opening of the canal, though the canal itself was never financially viable. Goods poured in from Pennsylvania and New York. There were dozens of wharves to hold the southbound ships.

The canal company opened a granite quarry in 1829 near the northern edges of the town. Its purpose was to supply materials for the bridges being built across the Susquehanna, but Port Deposit granite was used in buildings

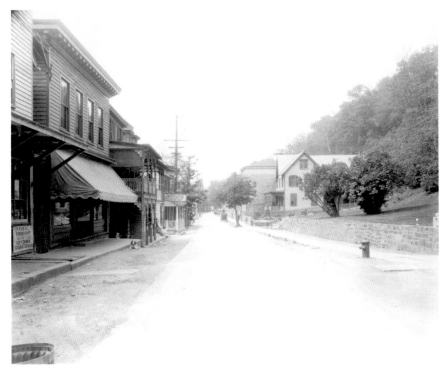

A view looking south on Main Street taken in 1905. *Photo courtesy of the Historical Society of Cecil County.*

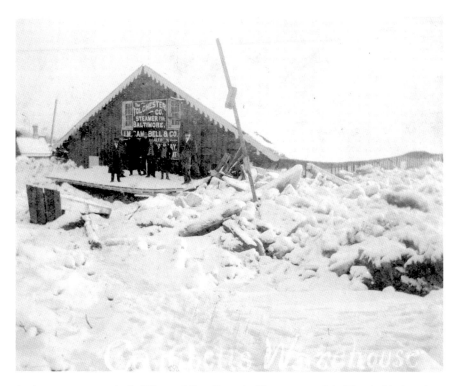

An ice gorge covers the buildings of Port Deposit. *Photo courtesy of the Historical Society of Cecil County.*

at the U.S. Naval Academy, the U.S. Treasury, the Boston Public Library and the Lincoln Tunnel. The entire complex of buildings that formed the Tome School for Boys, located on a hill above the town, was constructed using the local stone.

The Susquehanna Canal was closed for good in 1836, but shipping to and from Port Deposit continued. The period between 1830 and 1850 is considered to be Port Deposit's best years. As many as 1,500 arks and 1,000 rafts containing whiskey, lumber, coal and flour continued to navigate southward and arrived in Port Deposit each year.

Port Deposit would continue to grow and prosper through the Civil War years, but the seeds of its decline had been planted in 1832. The Baltimore and Port Deposit Railroad Company and the Delaware and Maryland Railroad were both incorporated that year. The purpose of the former was to connect Baltimore to the Susquehanna River, while the latter was to build a railroad from Wilmington to the east side of the river. The plan was to eventually create a rail line from Baltimore to Philadelphia.

The first section was opened by the Baltimore and Port Deposit Railroad in 1837, but despite the name, the company had chosen to terminate in Havre de Grace, bypassing Port Deposit. The Delaware and Maryland had merged with another railroad and was now called the Wilmington and Susquehanna Railroad Company. It had no choice but to run its Eastern Shore line to Perryville, directly across from Havre de Grace. A branch line to Port Deposit was eventually opened in 1866, but the town had been isolated by the railroads for thirty years. Products could be shipped at half the price and twice as fast on a rail car as they could be by using the canals. The change was slowly diminishing the importance of Port Deposit. The final blow came in 1926 when the Conowingo Dam was constructed a few miles farther up the Susquehanna River, eliminating any connection between Port Deposit and towns farther north along the river.

Port Deposit, built on a narrow strip of land between the river and the cliffs rising above the Susquehanna River, has been a constant victim of the river and Mother Nature. Ice gorges, large masses of frozen river water, would come down the river each winter, destroying everything in their path.

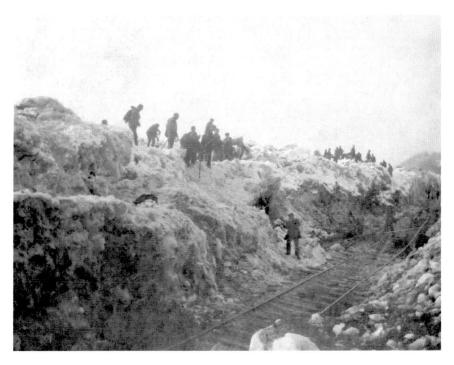

A crew is shown building the railroad spur through Port Deposit in the 1870s. *Photo courtesy of the Historical Society of Cecil County.*

The ice would be compressed as it squeezed through narrow passages along the river. Ice would rise up into central Port Deposit, swallowing buildings and uprooting streets. Flooding followed as the ice gorges began to melt. The most destructive ice gorge occurred in 1910, when most of the town and all of the town's records were destroyed.

Spring and summer were only marginally better. Heavy rains, some as far north as New York State, would send massive volumes of water downstream and into Port Deposit. The dams along the Susquehanna, including the final one, the Conowingo, were expected to control both the ice gorges and the floods. But the Conowingo proved to be a curse as much as a blessing. It normally opens a

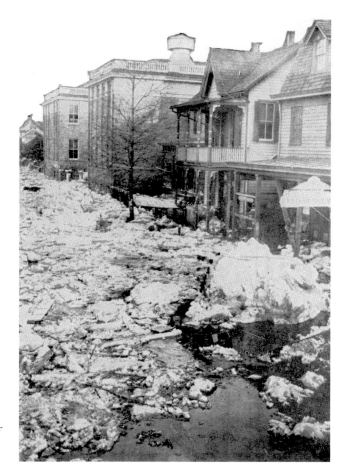

A view looking northward on Main Street during an ice gorge. *Photo courtesy of the Historical Society of Cecil County.*

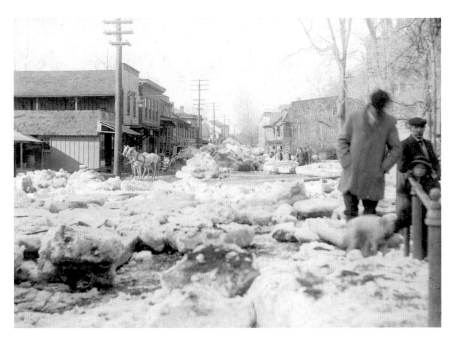

A 1910 view of two men walking through the ice in the streets of Port Deposit. A team of horses is in the background on the left. *Photo courtesy of the Historical Society of Cecil County.*

handful of gates to generate electricity, but in times of heavy rain, more gates need to be opened to drain the water from behind the dam. All fifty-four gates had to be opened during Hurricane Agnes in 1972, sending 650 billion gallons of water, silt and mud downstream, much of it ending up in the streets of Port Deposit. Today, the town is warned, with recommendations for evacuating, if the Conowingo Dam plans on opening more than a certain number of gates.

Port Deposit went through a small economic renaissance during World War II. The former Tome School for Boys was sold to the U.S. government and became the Bainbridge Naval Training Center. Thousands of navy recruits passed through during the four years of the war, creating hundreds of civilian jobs in the surrounding towns. The 1,200-acre base was closed in the 1970s and is now being redeveloped. Plans are for the creation of a mixed community of business and residential properties.

The biggest news in town during the immediate postwar years was on May 30, 1947, when an Eastern Airlines flight crashed outside of town, killing fifty-three people, including one man already dead. He had faked his suicide earlier that year. It was the worst commercial airplane disaster to date and happened less than twenty-four hours after an airliner went down outside of New York City.

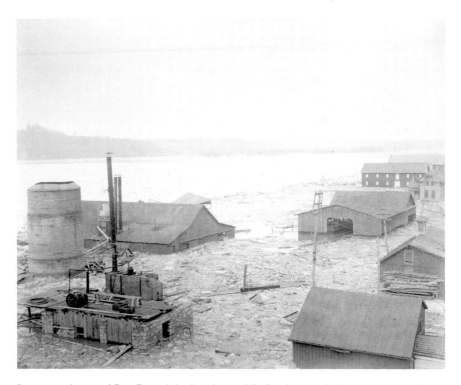

Ice gorges destroyed Port Deposit in the winter while floods came in the summer months. *Photo courtesy of the Historical Society of Cecil County.*

Wiley Manufacturing was built along the river in 1939, its primary business in shipbuilding. The sections of Baltimore's Harbor Tunnel were fabricated at the plant and then floated down the Chesapeake Bay from Port Deposit. The factory closed in 1981, but Tomes Landing, a community of condominiums with a marina, was built on the former Wiley site. It opened in the 1990s, bringing more people into town, at least on a seasonal basis. Restaurants and shops have opened as a result of the increase in visitors. There are recreational powerboats instead of freight barges today, but Port Deposit is still benefiting from being the last navigable port as you head up the Susquehanna River.

The U.S. Department of the Interior made a fitting tribute to this historic community in 1978 when it placed the entire town of Port Deposit on the National Register of Historic Places.

A Veteran's
Railroad Town

Y ou can tell a true resident of the mid-Atlantic region. We never refer to the land that separates the Chesapeake Bay from the Delaware Bay and the Atlantic Ocean as anything but the Eastern Shore. There are more books published about the Eastern Shore than any other section of Maryland, but an important fact is usually left out: Cecil County, home to both Perryville and Port Deposit, is part of the Eastern Shore. It was founded in 1674, making it older than many of Maryland's other counties, but it has become the stepchild of the region because, as John Wennersten says in his excellent book *Maryland's Eastern Shore, A Journey in Time and Place*, "Cecil County is different, more connected to the urban regions, more dominated by the state of Delaware than other parts of Maryland's Eastern Shore. The lifestyle is more working class than agrarian or maritime." The local TV stations are based in Philadelphia, and people tend to root for the Philadelphia sports teams rather than those in Baltimore.

People have lived along the east side of the Susquehanna River for centuries. Perry Point, overlooking the Chesapeake Bay and the mouth of the Susquehanna, was a Native American village off and on throughout history. The English colonists saw its potential immediately. London resident John Bateman received a patent for the land in 1658 and named it after his wife, Mary Perry Bateman, but first mention of the Point in documents was in 1661. Settlers were suffering constant attacks by the local Indians and held a meeting to discuss possible solutions. (Despite Bateman's ownership, the land was called Susquehanna Point during that assembly. The entire property is now referred to as Perry Point, but the tip of the land is called Stump Point on road maps and navigation charts.)

George Talbot had his own method of dealing with the natives. Talbot, a second cousin to Cecil Calvert, the second Lord Baltimore, obtained a

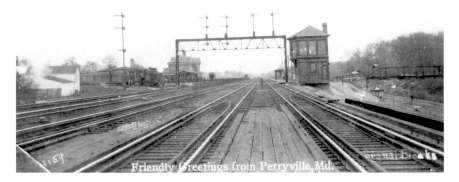

Perryville was proud of its status as a railroad town and its publicity photos reflected that attitude. *Photo courtesy of the Historical Society of Cecil County.*

patent in 1680 to what he called Susquehanna Manor, the thirty-two thousand acres between the North East and the Susquehanna Rivers that included the modern Perryville but not Perry Point. He ruled as if he was still a member of the English nobility, even forming his own group of rangers to fight the Susquehannocks. He ran into trouble when an English tax collector, Christopher Rousby, attempted to force the rule of the English Crown. Talbot solved his problem temporarily by stabbing Rousby to death. He was arrested and sent to Virginia for trial but managed a pardon because of his connections to Lord Baltimore. He may have been free, but he was extremely unpopular. Legend says that he avoided further prosecution by hiding in a cave along the Susquehanna River, where he was fed by two falcons. History fails to record Talbot's final days.

The future of the Susquehanna River Valley changed dramatically in 1670. The northern section of the Post Road, built to connect New England to the mid-Atlantic colonies, ended at the future site of Perryville. Edward Jackson, a captain in the colonial wars and a member of George Talbot's private army, the Susquehanna Rangers, settled along the east side of the river in 1678, calling his property Heart's Delight. The only way across the river was by private boats supplied by Jackson and others. They charged travelers exorbitant fees, and soon the public was demanding other arrangements. A new public ferry, located near the site of the modern Amtrak Bridge, opened

This was downtown Perryville in the early 1920s. *Photo courtesy of the Historical Society of Cecil County.*

in 1695 and linked the two sections of the Post Road. The town became known as Lower Ferry and, later, Susquehanna.

It is hard to understand today how important the Post Road and Lower Ferry were to colonial life. It was one of the few roads between colonies, and along with the Upper Ferry near Port Deposit, it was the only way across what was then the largest river in the country. Taverns and boardinghouses appeared along the road that supplied travelers with food, drink and a place to rest. Rodger's Tavern, originally known as Stephenson's Tavern or Ferry House, was opened by Colonel John Rodgers in 1740 at the east entrance of the ferry. George Washington's diaries note his visits to Rodger's Tavern. Rodgers raised and commanded the Fifth Company of Maryland Militia in 1775. They became part of the famous Flying Corps that aided Washington in the early Revolutionary days. As a result, the future Perryville became an important staging location for the Continental army. The colonel died in 1791, but his widow, Elizabeth, continued to operate the tavern. His son, Commodore John Rodgers, was the founder of the United States Navy. His estate, Sion Hill, overlooks Havre de Grace on the western side of the Susquehanna.

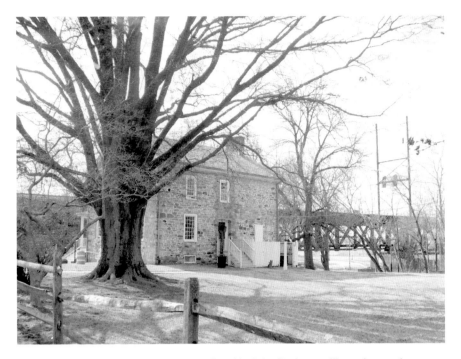

Rodgers Tavern, built along the Old Post Road by John Rodgers, still stands near the entrance of the Perry Point Veterans Hospital. *Photo courtesy of the author.*

John Bateman held the two thousand acres of Perry Point, the land between the Principio Creek and the Susquehanna River, until he sold it to Captain Richard Perry in 1720. (Some stories suggest that the name Perry Point came from this transaction, but Bateman was referring to the land as Perry Point ten years before the sale.) Perry passed the land to his children— John Perry, George Perry, Ann Templer and Dorothy Barren—in 1728. It was during this period that the Manor House, often incorrectly referred to as the Stump Mansion, was constructed. The house, registered as a national landmark, still stands. Phillip Thomas bought out the Perry family in 1729. The house stayed in his family until the late 1700s. It was purchased by John Holmes in 1799, who immediately sold it to George Gale.

John Stump purchased the property from Gale in 1800. He and his family lived in the Manor House for the next sixty-one years. It's around this time that the tidal-driven gristmill along the shoreline was constructed. It also still stands, and sailors draw a line from it to the Concord Point Lighthouse on the Western Shore to mark the beginning of the Chesapeake Bay and the end of the Susquehanna River.

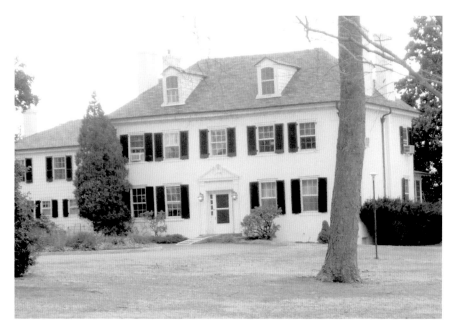

The Mansion House, known more commonly as the Stump Mansion, was built in the 1720s and still stands on the hospital property. *Photo courtesy of the author.*

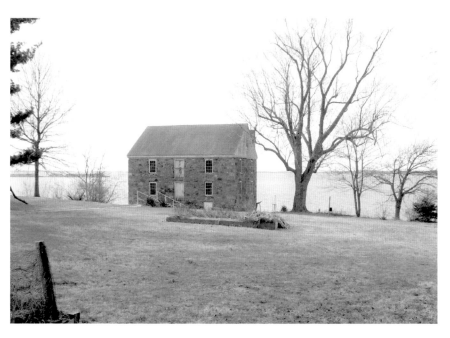

A tidal-driven gristmill was constructed as part of the Mansion House plantation. It still stands along the river. *Photo courtesy of the author.*

Perryville was still an insignificant community at the time of the War of 1812. The hurricane of 1786 had left the east side of the Susquehanna River near the mouth shallow and unsuitable for large boats. Port Deposit was the more important town because of its deep-water port, but the coming of the railroad in 1836 changed that dynamic. The railroads chose to terminate directly across from Havre de Grace, where northbound trains stopped, in order to have the shortest possible ferry ride for the freight and passengers. This increased the importance of Lower Ferry. A post office, listed as Chesapeake, was opened in 1837. Port Deposit was left isolated but still remained the more populated town for a number of years.

The Maryland legislature officially incorporated Perryville in May 1881 even though the population was only 250 people strong. The town was changing from a simple village to a full-blown rail center with switching yards and equipment barns. The ferry was replaced with the first railroad bridge in 1866. Growth was slow despite its importance as a major railroad junction point. Even with the addition of the B&O line in 1886, the 1890 population totaled only 340 people, but the next ten years would see the town's importance grow. The 1900 census showed 770 people. A train station was finally opened in Perryville in 1905. The major industry, besides the railroad, became ice. The town began cutting ice from the river about 1875, and it was soon shipping over 100,000 tons annually. Ice storage houses were in town along the river and on the north point of Garrett Island.

The Stump family's plantation life was disrupted by the Civil War. They were Southern sympathizers. The Union wanted the property at Perry Point for a mule depot and training center. Soldiers forcibly relocated the Stumps to Harford County, and the mansion was used as officer quarters. The soldiers entertained themselves by taking their swords to the custom woodwork and staircases. The house, which also featured a fireplace forged at the nearby Principio Furnace in 1771, suffered almost irreparable damage. At the close of the war, the estate went back to the Stump family. John Stump's ten children inherited the estate upon his death in 1896.

Highways began to appear in the early twentieth century. A section of the future Route 40, called the National Road, was constructed from Elkton to Perryville. The original railroad bridge was converted to vehicle traffic in 1906. It remained the main bridge for cars until the current Hatem Bridge was opened in 1940. Route 40, rebuilt as a four-lane highway, was relocated a mile north of downtown Perryville, which soon expanded to add businesses along the new route. Thousands of construction workers and navy personnel flooded the area with the opening of the Bainbridge Training Center near Port Deposit at the beginning of World War II. The population of Cecil

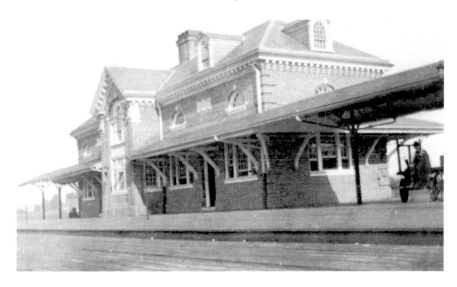

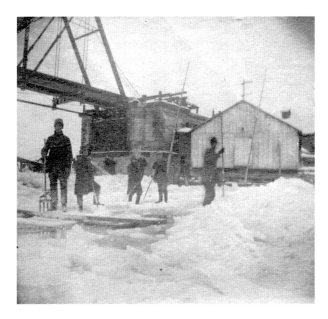

Above: The Perryville Train Station in 1905. *Photo courtesy of the Historical Society of Cecil County.*

Left: Ice was second only to the railroads in Perryville. Here a crew is cutting the blocks for shipment. *Photo courtesy of the Historical Society of Cecil County.*

County exploded by 225 percent in the 1950s, and Perryville expanded to include the former Frenchtown, Aiken and Gotham Bush in 1962, but the town would soon be bypassed again. The new interstate, I-95, opened in November 1963 and was located several miles north of Route 40. The town moved northward again with the construction of homes, hotels and an outlet center at the exit of the freeway.

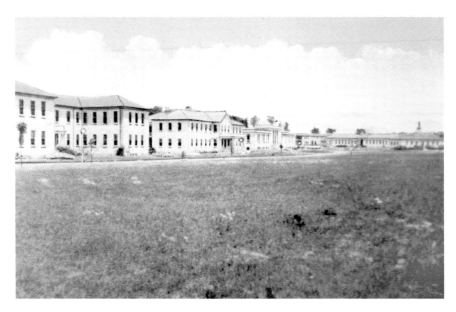

An old postcard showing the buildings of the Perry Point Veterans Hospital. *Photo courtesy of the Historical Society of Cecil County.*

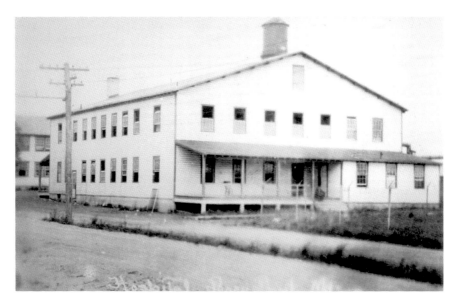

This was the original hospital building, which opened in the 1920s. *Photo courtesy of the Historical Society of Cecil County.*

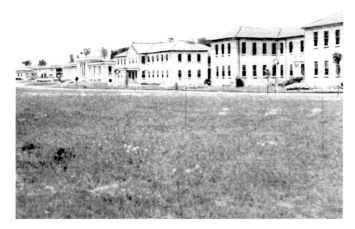

Another view of the Perry Point Veterans Hospital, showing some of the dorms for the patients. *Photo courtesy of the Historical Society of Cecil County.*

The Susquehanna Flats as seen from Perry Point. The barge is moored there and is used by the quarry north of Havre de Grace to store rock awaiting shipment farther down the Chesapeake Bay. *Photo courtesy of the author.*

The federal government returned to Perry Point in 1918, paying the Stump family $150,000 for 516 acres. It leased it to the Atlas Powder Company, which built and operated a munitions factory for the duration of World War I. The Veterans Administration took over the property at the end of the war and established a hospital. It first used the existing structures but broke ground in 1922 for a separate hospital building on the south end overlooking the Susquehanna Flats. It briefly renamed the land Federal Point, but the Stump family petitioned to have the original name remain. It has been Perry Point ever since.

A large veterans' hospital still stands along the southern shoreline near the actual point. The northern section of the property, near the Manor House, has streets lined with two-story houses. They overlook the Susquehanna River and were built as homes for the VA staff. Budget cuts have taken their toll. Other than a brief stay by the Americorp volunteers in the late 1990s, the houses have been all but abandoned, and the VA lacks the funds to even tear the buildings down. A movie company chose the site in 2006 as the perfect spot to recreate a town invaded by zombies.

Today, Perryville is a community of 3,600 residents. The old rail station reopened in 1991 as the last stop on the MARC commuter line that runs to Baltimore and Washington, D.C. Thousands of commuters pass through Perryville every week. The major local business remains the Veterans Hospital, but recently new shopping centers were built, a new library was opened and several of the local schools were remodeled and expanded. Perryville's location continues to be a positive element in the twenty-first century.

REVOLUTION CROSSES THE
SUSQUEHANNA RIVER

In the summer of 1776, fifty-six men, including four Marylanders, met in Philadelphia, and the world was forever changed. They produced and signed the Declaration of Independence, putting the thirteen American colonies at war with England. Among the first troops to join the colonial commander in Boston was the Fifth Company of Maryland Militia, formed in Cecil County in 1775 and led by Colonel John Rodgers. The Lower Susquehanna River Valley was to become a key contributor to the success of the American Revolution.

The four men from Maryland who signed the Declaration of Independence—Charles Carroll, Samuel Chase, William Paca and Thomas Stone—risked their lives in service to a greater cause, but there was no support greater than that of the people of the Lower Susquehanna River Valley. Colonel Rodgers's company became part of the famous Flying Cloud Corps. Many of the men lost their lives in battle. Another Cecil County leader, Colonel Jacob Hollingsworth, became a key fundraiser and supplier to the needs of the Revolution. There were more than 3,600 Revolutionary Patriots of Harford County; most of the healthy men served in the Continental army between 1775 and 1783.

Marylanders were confident in their ability to fight because of their successful participation in the French and Indian War, conducted between 1756 and 1763. Most of the battles in that war were farther west, but many local men had served under then major George Washington. Members of the militia were hardened veterans of battles fought with Susquehannocks. Those experiences, combined with an acute sense of patriotism, ensured that Harford and Cecil Countians would be active fighters against British rule.

This support, while not universal, was widespread throughout the region and existed despite one English law that benefited Marylanders. The law stated

that only British-owned ships could be engaged in trade between the colonies and England. The ships built around the Chesapeake Bay were considered British-owned, and the regulation helped local shipbuilders thrive, but when the First Continental Congress concluded, the Maryland Convention approved the work. There were three significant clauses: Marylanders would increase their output of wool in order to clothe themselves, reducing their dependence on England; militias would be formed; and Maryland would lend its support to any other colony in the fight against the British.

There were no battles fought in the Lower Susquehanna River Valley. The British did sail up the Chesapeake Bay and into the Elk River in August 1777. The town Head of the Elk, or Elkton, was a major supply depot for George Washington. The invaders seized the supplies and burned the home of John Ford, who was in charge of the troops guarding the outlets of the Elk and Susquehanna Rivers. The British also passed through and burned the few houses of Havre de Grace. They would revisit in 1813 and again set fire to the town.

Lafayette, the French army officer who provided invaluable leadership during the Revolution, was detached from Washington's army in March 1781. He and his 1,200 men made their way to Head of the Elk, where they managed to secure enough boats to sail to Annapolis. A few weeks later, they used two gunships to break through a British blockade and returned to the Elk River.

The traitor Benedict Arnold was wreaking havoc in the lower Chesapeake Bay. Washington ordered Lafayette to return south and attempt to eliminate him. Lafayette and his forces camped on the eastern shore of the Susquehanna near Port Deposit. They crossed the river at Bald Fry's Ferry just south of the Mason-Dixon line, pausing long enough on the Harford County side for Lafayette to hang a deserter. Lafayette would return after the war to the region that reminded him of a town in the north of France, leaving behind the name Havre de Grace.

Washington and his army passed through the Lower Susquehanna River Valley on their way to Yorktown in September 1782. It took two days for all of the men to cross using the one ferryboat at Lower Ferry near Havre de Grace. The war ended in 1783 with the British surrender. American independence was achieved with a considerable contribution from the people of the Susquehanna region.

1812

Author David Healey describes the feelings that Americans have toward the War of 1812 in the title of his excellent book on the subject. He calls it *Chesapeake Bay's Forgotten War*. Many people know that we fought a war in the year 1812 but don't know the details, and even more significant, many Marylanders don't realize that a great deal of the war was fought right here in their backyard. The attack on Fort McHenry is one exception, but most people know of it more because "The Star-Spangled Banner" was written during the fight than for the reasons for the battle.

The War of 1812 is a significant part of U.S. history despite our lack of interest. The British had never gotten over the loss of the American colonies during the Revolutionary War. Admiral Sir George Cockburn was sent to punish the American upstarts, marking the first time in history that one democracy attacked another. His strategy was to turn the Chesapeake Bay into an "English Pond" and make the American civilian population along the bay suffer. His royal marines used hit-and-run tactics, preventing the American militia from fighting back. He soon controlled the entire Chesapeake Bay.

The Lower Susquehanna River Valley would not escape the British aggression. In late April 1813, Cockburn and his fleet of warships sailed into the upper Chesapeake Bay and anchored near Spesutie Island. Five hundred royal marines were loaded onto barges and sailed up the Elk River. Their first task was to burn Frenchtown, a key port at the time because it was on the narrowest strip of the Delmarva Peninsula where goods could be cheaply transported from the Chesapeake to the Delaware Bay.

The British moved farther up the Elk River toward Elkton. This time the local militias were warned of their approach and were able to assemble a defense. They had mounted cannons at two locations, naming them

This is Furnace Bay. The British anchored here in 1813 and proceeded up Principio Creek to burn the ironworks located there. *Photo courtesy of the author.*

Fort Defiance and Fort Hollingsworth. A chain was stretched across the river to prevent the passage of the British vessels. The royal marines were peppered with shot as they attempted to reach the Little Elk River and the town of Elkton. The Americans prevailed; the British retreated and Elkton was spared.

The British weren't finished with the upper bay, though. They moved up the North East River, around Carpenter Point and into Furnace Bay, where Principio Creek empties. The upper end of the creek was home to one of the largest ironworks in the United States at the time. Cecil Furnace, originally called Principio Furnace, had the contract to build cannons for the U.S. Navy's first warships. The British attacked in early May 1813 and destroyed the sixty-eight cannons in stock, dealing a major blow to both the U.S. military and the owners of the ironworks.

The British moved farther west, anchoring off Havre de Grace on May 3, 1813. They attacked in the early morning hours, bombarding the town with rickets and cannonballs. In a story recounted on every restaurant menu in Havre de Grace, one man stepped forward to defend the town.

John O'Neill, an Irish immigrant and militia leader, who probably hated the British before the invasion, began firing back from a cannon located near where the Concord Point Lighthouse stands today.

His effort, while heroic, was doomed. He was injured and limped back into town, only to be captured by the British and held prisoner on one of the warships. Admiral Cockburn debated the fate of O'Neill while the British marines destroyed forty of Havre de Grace's sixty houses and most of the businesses and killed dozens of valuable farm animals. By law, any British subject, or former subject, was to be hanged for treason if he turned a hand against Britain. O'Neill's teenage daughter rowed out to Cockburn's ship to beg for her father's life. He decided to release him unharmed. The reason may have had more to do with American threats to hang British prisoners of war if O'Neill was hurt than his daughter's diplomatic efforts.

John O'Neill was rewarded for his bravery. When the Concord Point Lighthouse was built, he became the keeper for life. The job came with a stone house across the street from the lighthouse. After his death in 1837, the position passed to his descendants until the lighthouse was automated in the 1920s.

The British finished looting the town and sailed south, but the level of outrage among Marylanders increased after the attack on Havre de Grace. The war would continue for another year and a half and include the burning of Washington, D.C., but the tide in the war was turning. Each British raid became more difficult as locals fought back. Cockburn never expected to meet the resistance that he did in Baltimore. A treaty was signed on Christmas Eve 1814. (The final battle in New Orleans was fought two weeks later.)

The War of 1812 had a significant impact on the people and economy of the Lower Susquehanna River Valley, but it is largely forgotten. The United States was growing rapidly, and the recovery from the war was quick. The region was about to enter the boom years, and the battles quickly became a vague memory.

A STATE DIVIDED

It was July 1864. The word spread throughout the Lower Susquehanna River Valley. The Confederate armies had crossed the Potomac, captured Hagerstown, burned railroad bridges in Cockeysville and were headed toward Baltimore. They would seize the ferry that carried railroad cars across the river at Havre de Grace, giving them control of the upper Chesapeake Bay and a clear path into Philadelphia.

The plan would have worked except for the fact that Harry Gilmore, the Confederate major assigned to lead the 130-man raid, was a native of Towson. He stopped to visit his family before continuing on toward Baltimore. This gave the Union time to arm the citizens of Baltimore; move troops stationed in Wilmington, Delaware, to Perryville, where they could guard the ferry; and move gunboats, normally on the Potomac River, onto the Susquehanna, Gunpowder and Bush Rivers.

Gilmore's cavalry troops circled north of Baltimore, cutting the telegraph wires along Harford and Bel Air Roads. Gilmore had been given orders to commandeer the railroad bridge over the Gunpowder River. They arrived at the Gunpowder in time to capture a train coming out of Baltimore. The plan was to use it to raid Havre de Grace, but the train engineer disappeared. The cavalry set fire to the train and waited for the next one. It soon came, but the Havre de Grace Volunteers guarding the Gunpowder Bridge prevented Gilmore's troops from boarding. The Confederate troops set the second train on fire, this time sending it out onto the bridge. The Union forces aboard transport boats out on the river could do nothing but watch as the fire spread to the bridge. It collapsed into the Gunpowder River.

This was the second time that the Gunpowder River railroad bridge had been burned, and it was the second time that Harry Gilmore was involved in the fire. He had been part of a militia force ordered by the Maryland

governor, Thomas Hicks, to destroy the bridge in April 1861. Anti-Union mobs were attacking Union soldiers as they passed through Baltimore on the way to defend Washington, D.C. Hicks, along with Baltimore's mayor, George Brown, had asked Abraham Lincoln to route his forces around Baltimore, but when they did not hear back from the president, they took out the bridge, preventing Union troops from entering the city by rail.

The differences between the two burnings of the Gunpowder River Bridge point out the changing attitudes of Marylanders over the course of the Civil War. Officially, Maryland was a border state, one with a neutral stance on the war, but people were anything but neutral at the beginning of the war. The southern part of the state had a tradition of slavery, and Baltimore was considered to be the only Northern slave city, but most of the state did not have the large plantations that demanded the cheap labor of slavery. By the time the Civil War broke out in 1861, Maryland had a population of eighty-seven thousand free blacks, the largest population in North America.

Slavery may have been rapidly disappearing in Maryland, but the embracing of states' rights was not. Many Marylanders took up arms against the Union because they did not believe that the Federal government should be dictating policy to the states. Governor Hicks said, "I am a Marylander, and I love the union, but I will suffer my right arm to be torn from my body before I will raise it to strike a sister state." The bridge was burned in 1861 because the average Maryland citizen had decidedly Southern sympathies. By 1864, Maryland had been the site of several bloody battles. The Rebels had taken out their aggressions on the civilian population, and people were less supportive of the Confederates. They rushed to defend the Gunpowder River Bridge.

The Lower Susquehanna River Valley was much like the rest of the state—torn by the issues. Cecil County had one of the largest communities of free blacks, Snow Hill, and even though most of the small farms in Cecil and Harford Counties were not worked by slaves, a number of people had strong anti-Union feelings. John Wilkes Booth, born in the Harford County seat of Bel Air, was one of many residents who joined the Confederate cause. Those who stayed behind were strongly pro-Union.

With the exception of the multiple burnings of the railroad bridge over the Gunpowder, the Lower Susquehanna River Valley was spared the fighting. No great battles were fought in the area. There were no railroad bridges across the Susquehanna River in the 1860s. The Philadelphia, Baltimore and Wilmington Railroad hauled its cars across the river on ferries. The first ferry was named the *Susquehanna*, which was replaced by the larger *Maryland*.

It would be used after the 1861 burning of the Gunpowder River Bridge to carry Federal troops to Annapolis.

The towns of Havre de Grace and Perryville served as staging areas for the thousands of men and tons of supplies that would cross the Susquehanna River during the four years of the Civil War.

The current site of the Perry Point Veterans Hospital was used to train mules and their drivers. The militia and volunteers were stationed on both sides of the river to protect this key crossing, but with the exception of the scare caused by Major Harry Gilmore's Cavalry in 1864, their duty was peaceful.

The Civil War did produce one positive result for the Lower Susquehanna River Valley. It was recognized that the lack of a railroad bridge over the Susquehanna River had been a critical Union weakness. The first bridge was completed shortly after the end of the war. It opened up trade between Maryland and cities such as Philadelphia and New York. Port Deposit granite, lumber and locally caught fish could be transported inexpensively. The Lower Susquehanna River Valley had survived two wars, the Civil War and the War of 1812, and emerged stronger than ever from both. The second half of the nineteenth century would see a new level of prosperity for its towns and residents.

THE U.S. NAVY
COMES TO THE VALLEY

A driver, weary from the monotony of northbound I-95, might glance to the left as he crosses the Tydings Bridge over the Susquehanna River. He might notice a high bluff with large brick buildings overlooking the river. The buildings look old, but from this distance they look to be in good shape. The curious driver could exit the interstate in Perryville and follow Route 222 toward Port Deposit. He would drive past a large, wooded area surrounded by a rusty, chain-link fence displaying "No Trespassing, Federal Property" signs. The property is a jungle of undergrowth. Not much can be seen from the road, but you can catch a glimpse of the buildings in winter. They look less stately up close. They're rapidly decaying, with broken windows, falling porches and collapsing roofs. Vandals have stolen fixtures and set fires. It is impossible to imagine today, but as recently as 1945 thirty-eight thousand people lived on these 1,200 acres along the Susquehanna River. It was known as the United States Naval Training Center, Bainbridge. More than 500,000 naval recruits passed through the gates between its opening in 1942 and its final closing in 1976.

Bainbridge begins with the story of Jacob Tome. Tome was born penniless in Hanover, Pennsylvania, in 1810. He left school early and worked at a number of jobs before arriving in Port Deposit, Maryland, in 1833. He began to invest both time and money in the lumber industry. He moved on to find success in railroads and then founded a number of banks. He became Cecil County's first millionaire. He was also a philanthropist, giving money to a number of causes, particularly education. He founded the Jacob Tome Institute, later renamed the Tome School for Boys in 1889. It opened in Port Deposit in September 1894.

Tome died of pneumonia in 1898, leaving behind a fortune worth $2.5 billion in today's money, $3 million of it going to his namesake school. The

Where the River Meets the Bay

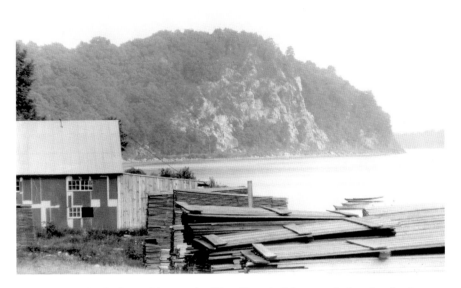

This is Mount Arafat, located just south of Port Deposit. It became the location for the Tomes School and then the U.S. Naval Training Center, Bainbridge. *Photo courtesy of the Historical Society of Cecil County.*

school's boards of trustees chose to build a private boarding school on top of a one-hundred-acre bluff overlooking the Susquehanna River. Thirteen Beaux Arts buildings, constructed with local Port Deposit granite, were built. These included classrooms, three dorms, a gymnasium with indoor pool and a hotel for guests. Under Secretary of the Navy Franklin Roosevelt would stay there when he was asked to speak to the students. The grounds, including an Italian garden, were designed by Frederick Law Olmsted, who also found time to lay out a small park in New York City, Central Park.

The school was initially a success, the 100 acres having grown to 335, but it fell on hard times during the Great Depression, and the trustees were forced to seek a buyer. Its availability reached the ears of now president Franklin Roosevelt. He was looking for an East Coast location to process the thousands of navy recruits as the country ground toward World War II. Congress had appropriated the money for three naval recruit–training stations, and the Tome School was purchased for $1 million. The U.S. Naval Training Center, Bainbridge, was born.

An old postcard shows the main buildings of the Naval Training Center. They were originally built for the private school envisioned by Jacob Tome. *Photo courtesy of the Historical Society of Cecil County.*

It was named for Commodore William Bainbridge, who had little connection to Maryland. The base size was increased through the addition of another one thousand acres acquired by condemning seventy-one nearby farms. The town of Snow Hill, the site of a pre–Civil War free blacks' community, was included in the acquisition. The Charles H. Thompkins Company of Washington, D.C., was hired to build four separate camps consisting of 506 buildings. The original school buildings overlooking the river were to be used by the Naval Academy Preparatory School (NAPS). The first of fifteen thousand workmen arrived on May 7, 1942. The first recruits arrived four months later on August 14, 1942. The cost of this massive building project was $50 million.

The end of World War II saw the base reduced to caretaker status, but it came back to life with the outbreak of the Korean War in February 1951. Up to a thousand recruits per week were sent through Bainbridge's eleven-week training course, but when this conflict ended, Bainbridge went back to its inactive status.

The navy did begin to use the property by establishing a number of important schools during the 1950s and 1960s. It was the only recruiting station for Women Accepted for Volunteer Emergency Service (WAVES). (WAVES were what the navy called its female members in this less enlightened age.) A nuclear power school was established, and it became headquarters to the Naval Reserve Manpower Command in 1963. The

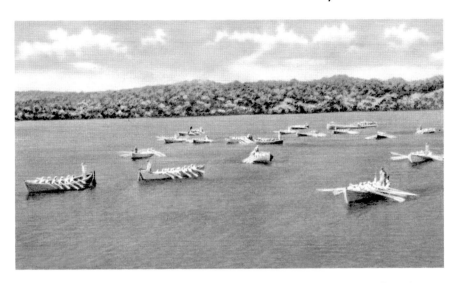

These navy recruits are conducting training exercises off the shoreline of Port Deposit. Susquehanna State Park now lies on the opposite shore. *Photo courtesy of the Historical Society of Cecil County.*

Service School Command, second only in operational size to the original recruit training program, was still operational in the 1970s. It offered courses for radiomen, fire-control technicians, postal clerks and quartermasters. By the late 1960s, Bainbridge was once again heading toward inactivity. The nuclear power school closed its doors in 1972, and the entire base was shuttered in 1976. The Jobs Corp. program used the school buildings for eleven years, and Cecil Community College found that the old base roads were perfect for its truck driver–training school, but these were short-lived uses. Planners posed other possibilities, including a prison, a NASCAR track, a film studio and a theme park, but none of these was practical. The base was enclosed with the chain-link fence and slowly retreated back to its original, overgrown condition. The secretary of the navy was authorized by Congress in late 1986 to find a buyer for the property with the goal that it would be reused to the benefit of Maryland and Cecil County.

Port Deposit residents took it upon themselves to start a clean-up effort and formed the Port Deposit Heritage Corporation. Each Saturday, a group of volunteers went to the old base and began removing the weeds and other debris choking the grounds around the original buildings. The Tome School Clean Up Volunteers consisted of people from all walks of life, from local farmers to state senators. Their efforts resulted in a remarkable transformation, but the base camps were too far gone to salvage. They were

built with a ten-year life span in mind, and forty years of abuse proved to be too much. They also posed a number of environmental hazards, including the widespread use of asbestos and lead paint. Bulldozers finished off what time had not. It was barely recognizable even by the Bainbridge veterans who returned for reunions.

Port Deposit annexed the base property into the town's borders in 1999. The Maryland General Assembly created the Bainbridge Development Corporation to be responsible for the redevelopment. The navy officially turned the base over to the state and Bainbridge Development in February 2000. The first move was to hire several well-known construction firms to work on stabilizing the Tome School Buildings. These companies, along with several other partners, formed a consortium with the goal of turning the base into a mixed-use facility of business, residential and light industrial. The State of Maryland provided loans to the project, but no real work was started.

The tired driver heading north on I-95 may see the buildings of the Tome School, but what he can't see are the thousands of sailors who once stood on the bluffs of Bainbridge looking down onto the Susquehanna River. They waited for the orders that would send them to the South Pacific or beyond. It's these men and women who passed through the training center that make Bainbridge a critical part of the history of the Lower Susquehanna River Valley.

SOUNDS ACROSS
THE WATER

Any resident of the Lower Susquehanna River Valley has had this experience. You have visitors from out of town. You're enjoying the outdoors on a warm summer day with a clear blue sky overhead. You hear a distant rumble but don't look around. The heads of your guests swivel as they scan the horizon for the thunderstorm. They look at you, wondering why you're not reacting. This happens several times before they get the nerve to ask, "Is it going to rain?" You reply, "Oh, that's just Aberdeen playing with their guns."

Aberdeen Proving Ground, located just five miles south of the mouth of the Susquehanna River and running sixteen miles along the Western Shore of the Chesapeake Bay, is the main weapon-testing and research facility of the U.S. Army. The property includes the Edgewood Arsenal, a chemical warfare development and disposal site. The functions performed on the seventy-six thousand acres of Aberdeen are too numerous to list, but its purpose is the research and development of systems for defense and fighting major wars and the testing of all types of military equipment used by all the branches of the armed services. You hear the results echo across the water.

The first gun was fired on what was originally called the Edgewood Reservation on January 2, 1918. Six months earlier, the land had been corn and tomato farms. It took two acts of Congress, two presidential proclamations and the efforts of Colonel Colden L. Ruggles, commander of the army's Ordnance Department, to turn thirty-five thousand acres of farmland and another thirty-four thousand of wetlands into a special type of army base.

The Ordnance Department had been doing all of its testing at Fort Hancock in Sandy Hook, New Jersey. It was too close to New York City, and space was needed for testing larger weapons. Secretary of War Newton

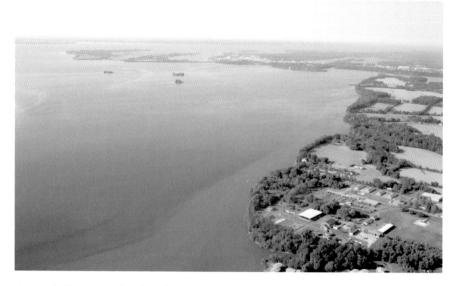

An aerial view shows Aberdeen Proving Ground stretching along the right shoreline. The island in the middle is Spesutie. It's now part of the Proving Grounds, but it was the site of several forts and later the famous Spesutie Island Rod and Gun Club. *Photo by Jane Thomas, IAN Image Library, www.ian.umces.edu/imagelibrary.*

Baker directed Colonel Ruggles to find a new site. It had to be near the manufacturing cities, all of which were on the East Coast, but far from major population centers. Ruggles thought of the Chesapeake Bay and initially selected Kent Island, but the residents raised enough objections that he looked elsewhere.

A friend suggested an area of farmland along the Western Shore near the town of Aberdeen and the existing Gunpowder Neck Reservation, later known as the Edgewood Arsenal. The proposed site had been part of the original land grant given to Lord Baltimore by King Charles I. Prior to the creation of the separate Harford County, the Baltimore County seat had been located along the Bush River that flows through the middle of the property. It was one of the most fertile stretches of ground in Maryland, producing an annual crop of tomatoes, wheat and a local corn called shoepeg worth an estimated $1.5 million. The farms had been in the families for generations, and they were reluctant to move, but an offer of $200 per acre changed their minds. Three thousand people and twelve thousand animals were moved to other parts of Maryland. Even family graveyards were relocated.

The army took official possession in October 1917. The initial mission was field-testing artillery, mortars and railroad-based weapons. An ordnance

school and small arms testing were added later, but the new proving grounds were barely organized when World War I ended in November 1918. Aberdeen began looking for peacetime work. It added the testing of powders, ballistics and projectiles. An airfield was constructed in the 1920s, as well as a hospital to serve the growing population of civilian and military personnel. President Roosevelt authorized money for expansion throughout the 1930s. The Ballistic Research Division opened in 1935. Aberdeen Proving Ground was becoming critical to the success of the army's overall mission.

The outbreak of World War II saw more growth. About 7,000 acres were purchased in 1942, and the 1,800 acres of Spesutie Island were incorporated in 1945. Thirty-five thousand military and civilian employees were assigned to the proving grounds by 1943, many of them women. More functions, such as armor testing, were added, but most importantly, the reputation of the Ballistic Laboratory was growing in the scientific community.

All testing functions of the U.S. Army were reorganized in 1962 under the United States Army Test and Evaluation Command (TECOM). Headquartered at Aberdeen, TECOM was responsible for the proving ground, as well as ten other test sites around the world. The Ordnance Officer Candidate School, the Land Warfare Lab, the Army Material Systems Analysis and the Human Engineering Lab were created in the 1970s. The most significant event was moving the Edgewood Arsenal, the army's chemical research and engineering center, under the command of Aberdeen Proving Ground in 1971. A separate land vehicle testing area was built in nearby Churchville. By the end of the 1980s, fourteen thousand people worked at what is now officially called the United States Army Garrison, Aberdeen Proving Ground (USAGAPG).

Aberdeen Proving Ground has not always been a welcome neighbor. Early in its history, shells were fired into the open Chesapeake Bay. Many failed to detonate, leaving unexploded ordnance across the bottom. Navigation charts warn boaters not to anchor because of the danger. Directly across the bay at the mouth of the Sassafras River is the town of Betterton, once a major resort in Maryland but now home to a number of expensive homes and condos. The residents have complained for years that test firings have damaged or destroyed their windows, a charge that has been consistently denied. There have also been a number of concerns raised about the environmental impact of the proving ground, especially Edgewood Arsenal. Chemical weapons were stored there for many years. Three senior officials were convicted in 1989 of violating a number of environmental laws. Millions of dollars are now spent annually for the cleanup, restoration and preservation of the grounds. It's one of the most beautiful shorelines on the Chesapeake Bay

and a prime nesting areas for bald eagles because it has been spared the rampant development common in other parts of the bay.

Aberdeen Proving Ground is Harford County's largest employer and that's unlikely to change. Base Realignment and Closure Effort, known as BRAC, will almost double the number of Aberdeen employees. While full-time army personnel will be added, the percent that they represent of the total will decrease as more functions are outsourced to various contractors and consultants. The mission of APG—the development and testing of weapons to ensure that soldiers in combat have the best available tools—remains the same.

WHERE THERE'S WATER, THERE ARE BOATS

The importance of the Susquehanna River as a means of transportation is not a phenomena conceived by the Europeans. The Native Americans had been exploiting its possibilities for centuries before the first settlers arrived. They constructed canoes by slowly burning a log selected from a loblolly pine or tulip poplar tree and scraping the ashes from the inside. Captain John Smith reported seeing log canoes as long as fifty feet. The British immediately saw the possibilities of using the log canoes to move heavy loads around the Chesapeake Bay. They improved on the design by joining together multiple logs to increase the capacity of the canoe and adding sails to increase the speed. They became the pickup trucks of the Chesapeake Bay. Examples of the canoes, built in the 1880s, are still raced on Maryland's Eastern Shore.

Captain John Smith explored the bay in a shallop, a term used for a common wooden vessel that could be rowed or sailed. Smith's twenty-eight-foot shallop had been brought to the New World in pieces and then constructed in Jamestown. When the Sultana Project in Chestertown, Maryland, decided to build a replica to recreate Smith's voyage, it had to rely on the few written observations and much guesswork since no plans could be found.

As more settlers poured into the region, boats became larger. The British primarily used large vessels falling into several broad categories with varying sail and mast configurations. There were barks, brigantines, frigates and carracks. Galleons, usually associated with the Spanish, were the largest and were usually referred to as a ship of the line or a first-rate vessel, meaning that it was a warship with at least one hundred cannons onboard. These deep-draft vessels could sail up to the mouth of the Susquehanna River as far as the site of the future Port Deposit because of the natural depth of the water.

The settlers soon began to develop specific boats that could traverse the mostly shallow waters of the Chesapeake Bay. The most common were the schooners, a design perfected by the Dutch but soon in widespread use in all parts of the world. There were two versions specific to the Chesapeake Bay. The pungy schooners originated in Virginia, but they were soon used around the bay. The principal usage of these two-masted, gaff-rigged vessels was to haul freight. They would sail north from Norfolk and Baltimore, making stops at ports along the way, the most northern being Port Deposit. They would meet boats coming down the river and return southward, as far as Bermuda, with a load of lumber, coal or produce.

The most famous of the Chesapeake Bay schooners were the Baltimore clippers. They were extremely fast boats built for rapid passages across the oceans, especially around the tip of South America to the West Coast of the United States. One unfortunate use was for the slave trade. These vessels, with deeper drafts than the smaller pungys, would also sail northward to the Lower Susquehanna River Valley in search of cargo. They were perfect for hauling the heavy timbers cut in the region to England.

We think of ferryboats today as large, motor-driven vessels capable of carrying hundreds of people along with their automobiles, but the first ferryboats used to cross the Susquehanna River at Port Deposit and Havre de Grace were pole boats. Raw timber planks were nailed to two or more logs that allowed the craft to float. A rope, stretched between shore lines, ran through a railing on the ferry. This kept the boat from floating down the river, but it had to be slackened when larger sailing vessels wanted to move across the path of the ferry. The crew would use long poles that would reach the river's bottom to push the ferryboat across the water. These vessels were small and could carry very little freight or even fewer passengers on each trip. Lafayette, and later George Washington, spent several days during the Revolutionary War crossing the Susquehanna River using the ferries.

Large boats could not navigate the Susquehanna River. Shippers in Pennsylvania depended on crafts built to float down the river, primarily in the months when the water was deep enough to allow free passage. The two main vessels were simple rafts and the more complex arks. An average year between 1750 and 1850 would see upward of three thousand of these boats entering the Lower Susquehanna River Valley, stopping primarily at Port Deposit.

There were three basic types of rafts. The spar rafts were as long as one hundred feet and were constructed by lashing a number of raw bark–covered logs together. The timber rafts were constructed of partially milled wood and shaped like railroad ties. The lumber rafts were made with totally

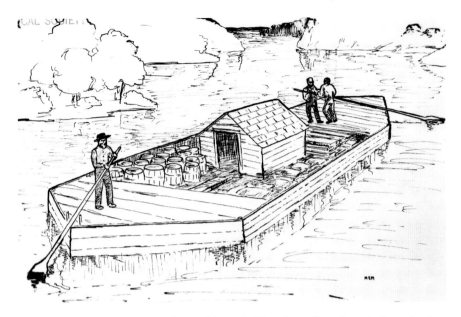

A line drawing showing a Susquehanna River ark. These boats floated goods down the river from New York and Pennsylvania, depositing their cargo in Port Deposit. The wooden arks were broken apart and sold as lumber. *Photo courtesy of the Historical Society of Cecil County.*

milled lumber. All three types were disassembled and sold after their trips down the Susquehanna, but the lumber rafts produced a more profitable return because the wood was ready to be used.

An ark—the name comes from the town of Arkport, New York—was an actual boat. They were usually around seventy-five feet in length and sixteen feet wide and could carry larger, heavier cargo such as produce, pig iron and coal. One report from 1800 claims that four arks brought four thousand barrels of wheat and two hundred of pork down the river from New York. Crews would have to be ready to go as soon as the spring melt produced enough water in the river. The trip south, when the river ran freely, took about eight days. They would tie up to the wharves in Port Deposit, sell the cargo, break the raft or ark apart for sale as lumber and then walk back north, a journey of about six days. The larger sailing vessels that worked the Chesapeake Bay would take the products to Baltimore, Norfolk or even back to England.

The canalboats used on both sides of the river were constructed much like arks. They were flat-bottomed with a small house built on the platform and were pulled up and down the canals by mules. Their size was restricted by the width and depth of the canals and locks.

The market value for the goods shipped south to Port Deposit on the arks and rafts totaled over $13 million in 1813, but by the 1830s, the railroads were beginning to eliminate the floating trade. The last ark was recorded in 1860. The 1890s saw the end of the rafts, though the last official trip was an ill-fated attempt in 1938.

The boats that made the run from Port Deposit to points south were also changing. The schooners became bugeyes, which evolved into the boat that is now Maryland's state symbol, the skipjack. These boats were built to dredge for oysters in the winter, but their wide beams and shallow drafts made them perfect for hauling freight around the Chesapeake Bay during the spring and summer. The dawning of the steamship age saw the old sailing vessels being replaced. The first steamship to visit the Lower Susquehanna River Valley was the *Chesapeake* in July 1813. The steamships also eliminated the old pole ferryboats. The railroads, lacking a suitable bridge, launched larger boats that could carry heavy freight across the river. The first of these was the *Susquehanna* in 1837. It was replaced by the larger *Maryland* in 1854, which was later used during the Civil War to move the Union army south to

A tug works the Susquehanna River in the early 1900s. They were used to pull barges from Port Deposit and Havre de Grace to locations farther south in Maryland. *Photo courtesy of the Historical Society of Harford County, Inc.*

Baltimore. The ferry service was eliminated entirely in 1866 when the first bridge across the Susquehanna River was opened.

Steamboats continued to visit the region in the twentieth century, but water transportation was soon replaced by the railroads and then the automobile. It was faster to jump in the car and drive from Baltimore to Havre de Grace than to ride a boat. Commercial vessels are largely absent in current Lower Susquehanna River Valley. Most boats are for pleasure, fishing, sailing, water-skiing or relaxing. The State of Maryland did subsidize a new ferry service that ran for a short while between Havre de Grace and Port Deposit, but a lack of paying passengers doomed the attempt.

Havre de Grace features two boats—the skipjack *Martha Lewis* and the stern wheeler *Lantern Queen*—that offer public cruises from May until the end of October. The only true remaining commercial boats are the large tugs that move barges filled with rock from the quarry on the Western Shore near the I-95 Bridge to crushing plants around the Chesapeake Bay. Boats and boating are still important parts of the local economy. There are four marinas in Havre de Grace, two in Perryville and one in Port Deposit, but their purpose is to serve the weekend pleasure boaters. The golden age of river transport is well in the past.

Up and Down the River

M any of the large tributaries of the Chesapeake Bay are blocked at the fall line. The James, the Potomac and the Susquehanna contain waterfalls and massive numbers of boulders that limited access to the upper reaches of the rivers. It was obvious to the earliest settlers that a key to the growth of what would shortly become a new country was finding a way around these trouble spots. Canal building was the answer. By 1793, there were thirty canal companies operating in eight states. All were financial failures, but they were still a driving force in the growth of the communities they served.

One of the first charters for constructing canals was issued to the Potowmack Company in 1785. George Washington was one of the partners, having surveyed the Potomac as a young soldier. Its purpose was to build what would become the 340-mile-long C&O Canal. The original vision was to connect the Chesapeake Bay to the Ohio River. It ended up falling short of that goal, with the final version starting in Cumberland, Maryland, and running to Georgetown in Washington, D.C. It cost $22 million to build and lasted for ninety-six years.

The Susquehanna River presented both a challenge and an opportunity. The first European settlers in the Lower Susquehanna River Valley knew that the river held the key to economic prosperity. Pennsylvania was rich in lumber and coal. A fortune could be made if a way around the fall line could be found. Valuable cargo could come down from Pennsylvania and New York and be transported and sold in Baltimore, Norfolk and Richmond.

The first formal attempt began in 1783 with the building of the Conowingo, a mile-long channel that sent river traffic around the falls in southern Pennsylvania. That same year, the Susquehanna Company was chartered. It was to build a canal, thirty feet wide and three feet deep,

running from the state line, where it would connect to the Conowingo, down to the mouth of the river, defined in the documents as the tidewater. The work was to be completed by 1790. A fight immediately began between the two sides of the river. Havre de Grace and Port Deposit both understood the benefit that a canal could bring to their towns. The east side won the initial argument, and the Susquehanna Canal, later called the Maryland Canal, was the result. The work was started in 1783, but construction took twenty-two years instead of the planned seven. When it was completed and opened in 1805, it ran from Love Island, just below the state border, to Port Deposit. It never reached Perry Point, five miles farther downriver, as originally planned. It made Port Deposit one of the largest ports in Maryland. Dozens of boats came down the canal each day and were met by ships that would reload and sail off to major ports farther south.

The value of the goods that reached Port Deposit by canal in April through June 1817 was placed at $1.8 million, but the canals were never a success. The canals fought the same two issues that plagued the river itself: too much or too little water. They had to be drained in the winter months to prevent ice damage. The Susquehanna River's current ran quite swiftly, especially in the spring (this was before any dams were constructed for flood control), and because the forests of Pennsylvania were rapidly being cut down and shipped south, the runoff of the land caused silting. The canals had to be constantly dredged. The dry summer months meant that there was not enough water for barges to get through. The return on the investment was insufficient, and in 1817, the Susquehanna Canal was sold at a sheriff's sale.

It returned to operation as the Maryland Canal and was prosperous enough that the granite quarry, which had first opened in 1806 on the north edge of Port Deposit, was purchased in 1829 by the canal. Granite was soon being shipped off to be used in the construction of bridges and buildings. The success was short-lived, and the canal was closed for good in 1836, driven in part by the construction of the Susquehanna and Tidewater Canal on the Western Shore.

The Tidewater Canal Company was incorporated in 1835 in Maryland. Pennsylvania chartered the Susquehanna Canal Company in the same year. It jointly opened in 1839 as the Susquehanna and Tidewater Canal. It ran the forty-five miles between Havre de Grace and Wrightsville, Pennsylvania. It had twenty-nine locks, each 150 feet long and 18 feet wide, that raised the boats up 233 feet between the two ends. It cost $3.5 million to construct, making it the third most expensive canal ever built in this country.

The Susquehanna and Tidewater Canal ran along the western shore of the Susquehanna River from Havre de Grace to Wrightsville, Pennsylvania. The B&O Bridge is in the background. *Photo courtesy of the Historical Society of Harford County, Inc.*

Revenues from toll collections grew from $42,000 in the first year to more than four times that in 1850, but like its predecessor across the river, it was plagued by financial issues. The debt caused by the building costs and an initial lack of capital was unmanageable. The profit picture was not improved when the new canal was damaged by floodwaters in its first year and was closed until 1840. Its best year was 1870, but average revenues had begun to fall after 1855. The combination of the Civil War that shut down trade between the Southern state of Maryland and the Union stronghold of Pennsylvania and the coming of the railroad doomed it to failure years before it closed. The Pennsylvania and Reading Railroad purchased it in 1872 and used it to haul coal to Baltimore. (One of the ironies of history is that the canals made a great deal of money hauling the supplies for building the railroads, the very industry that would put them out of business.) It continued to operate until 1900. The Susquehanna River would return to its natural state as a one-direction waterway.

THE RAILROADS ARRIVE
(AND SO DO THE BRIDGES)

Visitors to the Lower Susquehanna River Valley invariably ask the residents, "Doesn't the sound of the train bother you?" The answer is "What train?"

Two rail tracks cross the Susquehanna River. Amtrak and the MARC Commuter trains use the lower bridge passing through Perryville and Havre de Grace, and the upper bridge, just south of the I-95 Bridge, carries freight trains. Another freight track runs along the east side of the river from Perryville through Port Deposit and on into Pennsylvania. The tracks are busy, especially the Amtrak line, which handles the Boston–Washington, D.C. service. Train whistles are in constant operation as they reach grade crossings and warn people of their approach. There is even one Havre de Grace restaurant that uses its proximity to the railroad bridges as a selling point—"Eat where you can watch the trains"—but locals have long since tuned out the sound. Railroads have been a fixture in the area since the 1830s.

The excitement of the canals disappeared almost as soon as the first one opened in 1805. They were never a financial success, and in the mid-1800s people began looking for a workable substitute. The valley did not want to lose the economic momentum that the canals had provided. The railroad boom was about to begin. (Of course, the railroads needed a way to move the supplies required to build the right of way and hired the canals to haul rail ties, rails and ballast.)

The first railroad, the Baltimore and Port Deposit, was chartered in 1832. Its purpose, as the name implies, was to carry people and products from Baltimore northward to the Susquehanna River. The Delaware and Maryland Railroad was created the same year to connect Wilmington to the river. It merged with the Wilmington and Susquehanna in 1836, which had begun construction of a line between the Delaware River and Charlestown,

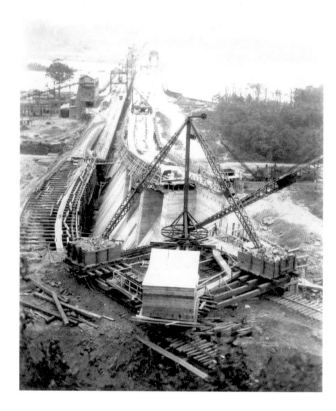

The original railroad bridge, built by the Philadelphia, Wilmington and Baltimore Railroad in 1866, is being constructed. *Photo courtesy of the Historical Society of Harford County, Inc.*

Maryland. The Baltimore and Port Deposit changed its terminus to Havre de Grace, where the shoreline was less rugged. The Wilmington and Susquehanna, in a decision that was central to the future growth of Perryville and Havre de Grace at the expense of Port Deposit, chose to build beyond Charlestown to Perryville.

The Philadelphia, Wilmington and Baltimore Railroad Company completed a line in 1837 connecting Philadelphia to Wilmington. Trains could move north and south from Philadelphia to Baltimore and soon into Washington, D.C., using the three separate railroads. In 1838, all three lines were consolidated under the Philadelphia, Wilmington and Baltimore name. There was one major stop at the Susquehanna River.

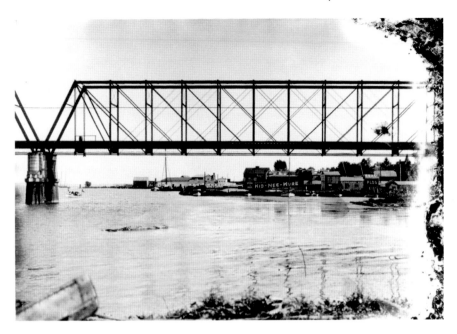

The same bridge, now completed, with Havre de Grace in the background. *Photo courtesy of the Historical Society of Harford County, Inc.*

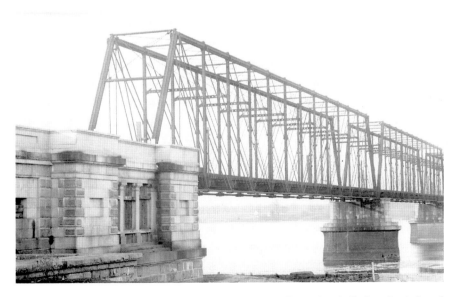

A closer view of the same bridge. It was purchased by the Pennsylvania Railroad, reinforced and eventually sold to the state as a highway bridge. The piers still stand. *Photo courtesy of the Historical Society of Harford County, Inc.*

The dream of crossing the river was always as strong as the vision of harnessing the river. Ferries existed at Port Deposit and at Perryville as early as 1695, but the boats could only hold a few people and their reliability was subject to changes in the weather. The problems that the armies of George Washington had crossing the Susquehanna during the Revolutionary War pointed out the strategic weakness of having no reliable method of traversing one of the major rivers of the country. The Port Deposit Bridge Company was chartered in 1816 to find a suitable place for the construction of a bridge. It was to be located somewhere between Havre de Grace and what was known as Bald Fry's Ferry, just below the Maryland line.

The final site was surveyed in 1813. It would run from a spot just north of Port Deposit to Lapidum in Harford County using several islands in the river as intermediate stops to reduce the overall construction costs. It would measure one mile long and would be used for foot and horse traffic. Work began in 1816 and was finished two years later. The piers used Port Deposit granite from the newly opened quarry. The bridge, formally known as the Rock Run Toll Bridge, was destroyed by an 1823 fire caused by sparks from a speeding iron-shod sleigh. The reconstruction took until 1829. It operated until 1854, when it was again damaged, this time by the weight of a herd of cattle crossing the river. The remains finally were washed away by the flood of 1857.

Another bridge, the Conowingo Bridge, was constructed farther north, two miles above the current location of the Conowingo Dam. The 1,334-foot bridge opened in 1844 but was destroyed by a flood in 1846. A new covered bridge was opened in 1859, just in time for the Civil War. Union troops were assigned to guard the bridge to prevent use by the Confederate army. They removed some of the floor decking and wired the spans with explosives. It continued in operation until arsonists set fire to it in 1907. A steel structure replaced it in 1909. The rising waters behind the new dam doomed the bridge, and it was brought down by dynamite in 1928.

The railroads continued to operate by moving their freight and passengers across the river on ferry barges, but they were never at a loss for creative solutions to the problem of crossing without a bridge. The winter of 1852–53 was so harsh that the Susquehanna froze solid, providing several feet of ice as a platform for rail tracks. They were laid across the frozen river, and for two months freight could pass freely between Philadelphia and Baltimore.

The Civil War showed that the lack of a suitable railroad bridge was still as much of a strategic problem as it had been eighty years before during the Revolutionary War. Troops had to cross either using the Conowingo, twelve miles above the rail lines, or go across in small groups on the ferries owned by the railroads. The railroads conducted a survey after the Civil War to find

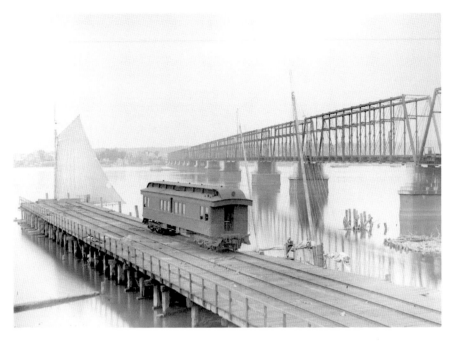

A view of the PW&B Bridge from Perryville. The passenger car is waiting for the ferry. It looks as if a skipjack is tied to the end of that pier. *Photo courtesy of the Historical Society of Cecil County.*

a suitable location for a bridge. The Susquehanna Bridge, located near the current Amtrak Bridge, was completed in 1866 and connected the railroads in Perryville to those in Havre de Grace. It was only operational for a month before a tornado brought it down. It reopened in November of that year to traffic from the Philadelphia, Wilmington and Baltimore Railroad. The Pennsylvania Railroad purchased the single track and wooden bridge and reinforced it with iron in 1874.

The Pennsylvania Railroad and the Baltimore and Ohio (B&O) were the two great corporations of the late 1800s. The Pennsylvania was first chartered in 1846 to provide rail service from Philadelphia to Harrisburg, Pennsylvania, later expanded to include an extension to Pittsburgh. By the beginning of the twentieth century, the company had grown to be the largest publicly traded company in the world with 250,000 employees, ten thousand miles of track and business relationships with more than eight hundred other railroads, including the Philadelphia, Wilmington and Baltimore. The Pennsylvania leased its tracks in 1873, but in the early 1880s it conducted a full stock buyout. This included a spur connecting the mainlines to Port Deposit, first built by the Columbia and Port Deposit Railroad in 1867.

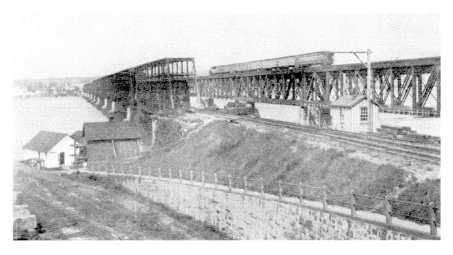

The old and new Pennsylvania Railroad bridges that once crossed the Susquehanna River between Perryville and Havre de Grace. The new one, built in 1906, is still in use. *Photo courtesy of the Historical Society of Harford County, Inc.*

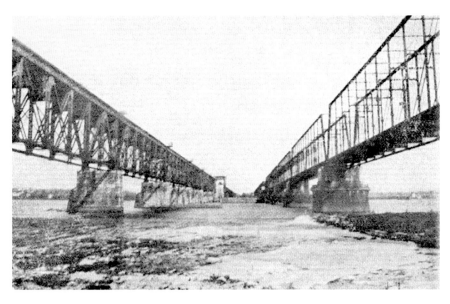

Another view of the old and new bridges. The old was torn down in 1943. *Photo courtesy of the Historical Society of Harford County, Inc.*

Where the River Meets the Bay

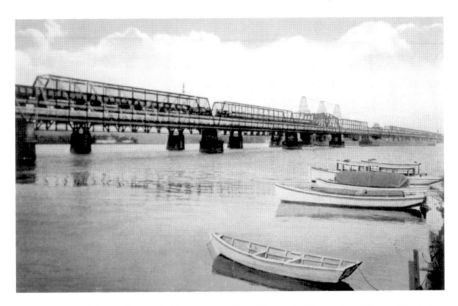

An old postcard shows the two bridges as seen from Havre de Grace. A public parking lot is located at this site today and provides much the same view. *Photo courtesy of the Historical Society of Harford County, Inc.*

The Baltimore and Ohio began in 1827, when Phillip Thomas and George Brown, along with twenty-five other Maryland-based investors, secured a charter for a railroad that would reach the Ohio River. They expanded the charter in 1831 to include a Baltimore-to-Washington route. The early investors had aggressive plans, but the railroad was losing money until John Garrett was appointed president in 1858. The stockholders began receiving dividends in his first year because of his ability to slash costs.

The B&O continued to expand westward after the Civil War but was concerned about losing its vital connections to northeastern cities such as Philadelphia, a fear that became a reality when the Pennsylvania Railroad bought the Philadelphia, Wilmington and Baltimore in the early 1880s. The B&O chartered the Philadelphia Branch in Maryland and the Baltimore and Philadelphia Railroad in Pennsylvania and Delaware. These new subsidiaries allowed the B&O to operate its own continuous line between Washington, D.C., and Philadelphia by 1886. This included a bridge across the Susquehanna River, described at the time as one of the largest man-made structures in the world. It was a behemoth at 6,348 feet long and soared 94 feet above the water at low tide. Many of the piers supporting the bridge were located on Palmer's Island, quickly renamed Garrett Island in honor of the B&O president who died that year. The bridge would be rebuilt

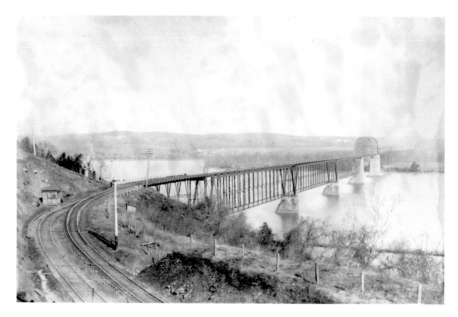

The B&O Bridge, built in 1886, was described as one of the largest man-made structures in the world. *Photo courtesy of the Historical Society of Harford County, Inc.*

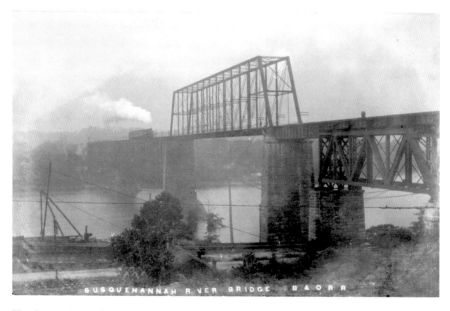

The Susquehanna River Bridge is shown in this photograph. *Photo courtesy of the Historical Society of Harford County, Inc.*

to handle heavier freight cars in 1907, but sections of it collapsed, taking eleven coal cars with it. A new double-tracked bridge opened in 1910.

The Pennsylvania Railroad replaced the 1866 single-span bridge across the Susquehanna in 1906. The state and two local counties refused an offer from the railroad to take over the old bridge at no cost. Seven stockholders, including the brother of the governor, purchased it in 1908. The Havre de Grace and Perryville Bridge Company removed the tracks and converted the bridge to vehicle traffic. The renamed Gold Mine Bridge took in $101,000 in tolls in 1921. The state did decide to purchase it for $500,000 in 1923. It added a second deck above the original to allow for simultaneous north- and southbound traffic. It was successful enough that the tolls were soon eliminated. It closed in 1940 but remained in place until it was torn down in 1943 and sold as scrap metal to be used for war efforts. The old piers are still visible.

The Pennsylvania Railroad bought a controlling interest in the B&O in 1901. It continued to operate as separate organizations for the next sixty years, but like the canals, its days as corporate giants were numbered. An event little noticed by their executives occurred in August 1940. The new Route 40 Bridge, named the Susquehanna River Toll Bridge, opened for vehicle traffic. Cars and trucks were increasing in popularity, highways were

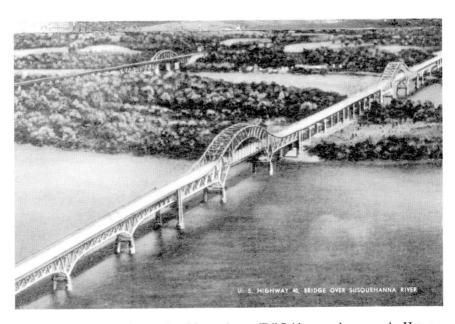

This view shows the newly completed Susquehanna Toll Bridge, now known as the Hatem or Route 40 Bridge. Like the B&O Railroad bridge to the left, it uses Garrett Island to rest some of its piers. *Photo courtesy of the Historical Society of Harford County, Inc.*

being built to meet the demand and the railroads were losing vital passenger and freight revenues.

The B&O merged with the C&O in 1963. It, along with several other railroads, operates today as CSX. The Pennsylvania merged with the New York Central in 1968, but a combination of bad management, poor financial resources and the withdrawal of a $200 million government loan forced the Penn Central into bankruptcy in 1970. Amtrak and Conrail were created using the assets. Conrail was broken up in 1999, and the portion that had been property of the Pennsylvania Railroad became part of Norfolk Southern. Amtrak continues to operate passenger service. There are now five Susquehanna River crossings in the Lower Susquehanna River Valley, two rail bridges, two highway bridges and U.S. Route 1 across the Conowingo Dam. The upper railroad bridge, whose piers rest on the northern edge of Garrett Island, is the old B&O Bridge. It soars high above the river and is part of the CSX system. Amtrak's heavily used Northeast Corridor between Boston and Washington, D.C., crosses the Susquehanna River on the 1906 bridge built by the Pennsylvania Railroad. It's a swing bridge, with fifty-three feet of clearance above the water, and is used by the local Maryland commuter trains, the MARC, as well as Amtrak. Amtrak must open it for larger boats to pass through. A maintenance crew goes out on the bridge, unwelds the rails, swings it open and then repeats the process after the boat has passed. North- and southbound trains are held until the boat passes safely through the bridge.

On January 17, 2008, President-elect Barack Obama added a footnote to the history of the Lower Susquehanna River Valley when his inaugural train used the 1906 Pennsylvania Railroad Bridge to cross the Susquehanna River on the way to Washington, D.C., following the same route Abraham Lincoln took in 1861.

The mile-long I-95 or Millard E. Tydings Bridge was built between January 1962 and November 1963. Millard Tydings was a local resident who served as a U.S. senator in the 1920s. It's estimated that the bridge carries twenty-nine million vehicles a year. The Route 40 or Hatem Bridge opened in 1940 as the Susquehanna Toll Bridge, replacing the double-decked one constructed from the old railroad bridge. Its piers, like the ones for the B&O/CSX bridge, rest on Garrett Island. It's named in honor of Thomas Hatem, a local Harford County dignitary.

Today, more than 160 million tons of freight and close to 500,000 passengers cross the Susquehanna River every year. The glory days of the railroads may have passed, but the locals still hear the mournful cries of the train whistles, a sound heard for over 150 years.

WOOD, ROCK AND COAL

The dream of harnessing the Susquehanna River for inexpensive transportation existed as soon as the first Europeans arrived in the 1600s. It finally became a reality two hundred years later with the construction of two canals. The United States was growing. People needed lumber and stone for building and coal for the furnaces of the heavy industries. Pennsylvania had what seemed like an abundance of both. Towns such as Port Deposit and Havre de Grace would be the outlets for these resources for the rest of the country, and the Lower Susquehanna River Valley would see its strongest economic growth in the 1800s. This would come at a cost. The exploitation of these resources is one of the biggest contributors to the decline in the quality of both the river and the Chesapeake Bay.

Forests cover about 60 percent of Maryland today. None of it is old growth, and most of it is fragmented—groves of trees separated by miles of farmland or suburban sprawl—but when the first settlers arrived in this country, they found a land that was covered with mature forests. Huge oak, cypress and chestnut trees with eighteen-foot circumferences dominated the countryside. Sumac, sassafras and laurel ran along the shorelines of the rivers and bays. While the Native Americans did their share of cutting and burning, Maryland and the other eastern states were shaded by an unbroken canopy of trees.

The early settlers immediately set out to cut down as many trees as possible. They were impediments to farming and frightening to travel though. Stories such as "Hansel and Gretel" and "Snow White" existed because the forests of Europe were dark, forbidding places that were to be avoided. Europeans even feared the rich soil that covered the forest floor, believing it contained dreaded diseases. The eradication began the moment they landed. The land needed to be cleared for small farms and there was

Millions of board feet of raw timber came down the Susquehanna River. This pile of logs is in Port Deposit, waiting to be milled into lumber. *Photo courtesy of the Historical Society of Cecil County.*

a growing need for firewood, but the largest impact to the native forests was the introduction of tobacco. Tobacco wears out the soil in seven years or less. Growers needed to clear land quickly in order to keep up with the demand for the plant.

Tobacco was the major export to England in the 1700s, but lumber would soon become second in shipping volume. England had been virtually deforested. Firewood had quadrupled in price, and the shipbuilders, who needed as many as two thousand oak trees in the construction of a warship, were having trouble finding suitable timber. English industries such as brewing, baking, glass blowing, mining and building construction created a further increase in demand. The Baltic States had been a source of lumber, but the constant political maneuvering in Europe had made the area unreliable. Eyes naturally turned to the American colonies and their vast forests.

The Susquehanna River system contained an estimated seven hundred billion feet of lumber in colonial times. The trees of northern Maryland were the first to be cut down as small farms appeared, but the Lower Susquehanna River Valley saw its first economic boom because the wood from the even larger forests of Pennsylvania, particularly along the West

Branch of the Susquehanna River, had to be shipped. Twenty-five million board feet passed through the valley on their way to Baltimore in 1820 alone. As a result, the population grew from five thousand in 1770 to more than seventy-five thousand thirty years later.

Logging started slowly. At first it was primarily small landowners who would clear their own property and sell it, but the 1830s saw a shift in the financial viability of logging along the Susquehanna River. The demand for timber was increasing both here and overseas. The inherent dangers involved in the industry were offset by the prices that buyers were willing to pay. Large companies that owned both the timber and sawmills were created. The annual floodwaters of the river were used to send fresh, clear-cut logs down the West Branch and into the main stem. As many as thirteen thousand logs would be bound together in huge rafts. The floating logs, tended by as many as ten thousand men, would then be trapped in booms in Williamsport and Wrightsville, Pennsylvania. A boom could hold enough wood to build 534,000 modern homes. The logs would be pulled from the water and sent over land, first in wagons and later on trains, to sawmills.

Each year, thousands of board feet escaped the booms and ended up downstream in the Lower Susquehanna River Valley. John DuBois, the namesake of a former lumber camp that became DuBois Pennsylvania, had amassed a fortune of more than $20 million from the timber industry, but he lost thousands of dollars in income every time an upstream boom broke. More than 4.5 million feet ended up at the mouth of the Susquehanna in 1860. DuBois solved the problem of the losses by constructing a log pond and sawmill in Havre de Grace, located where Log Pond Marina sits today. Loggers were hired to pull the escaped logs into the retention pond, where they could be stored until cut.

The outbreak of the Civil War increased the demand for lumber. This trend continued into the postwar recovery years, but the edges of the industry were beginning to fray. The financial panic of 1873 put many lumbermen into bankruptcy. The unions were applying pressure to the sawmill owners to cut the workday down from ten hours to eight. Railroads were being built into the forests. They could haul the cut logs out to market more cheaply, and safely, than the log rafts and booms on the river. And the quality of the timber was declining. White pines had been the trees of choice, but as they disappeared due to overcutting, there was an increasing number of hemlocks. The hemlock was not considered a good wood for building and initially was cut mostly for its bark. Carpenters found a way of successfully getting hemlocks to hold a nail in the 1880s, but logging on the Susquehanna was on its way out. The State of Pennsylvania recognized

that one of its most valuable resources was being eliminated and passed the first environmental laws designed to preserve at least some of its forests. The industry was virtually dead by 1913, and the sawmill in Williamsport, which had once employed more than two hundred men, cut its last log in 1919.

Logging may have been dying, but it was being replaced by a new resource that had to be shipped down the Susquehanna River. More than one hundred billion tons of anthracite coal lay along the North Branch of the river. The fifty-mile stretch of the Wyoming Valley had more than seven billion tons. The industry output doubled every year between 1850 and 1890. While the railroads hauled much of the coal, the Susquehanna River saw its fair share come down the river on coal barges to be offloaded onto larger vessels. The Bethlehem Steel plant at the entrance to the Patapsco River in Baltimore was just one of many consumers of Pennsylvania coal.

Coal production shifted to the fields in the western part of the United States in the early twentieth century, but the impact of coal, and its waste products, was left behind. The water used in coal mining eventually washes out of the mine and into any nearby stream. The result is a serious increase in acidity that turns the stream into a dead zone. A 1917 survey estimated that the bottom of the North Branch contained fifteen to twenty-five feet of coal silt. Each year it was swept down the river by the current. A fleet of steamboats and barges, called the Hard Coal Navy, operated until the 1950s, dredging the bottom of the river near Harrisburg, raising as much as 300,000 tons of coal particles out of the silt.

The economic benefit of coal mining to the Lower Susquehanna River Valley came from the shipping revenues, but the quarrying of granite was a local industry. Port Deposit Granite, a quartz-rich biotite granodiorite, is the result of molten masses known as magma that began to cool 300 million years ago. The slow cooling process formed the large crystals that make this type of granite so distinctive. The light bluish hue and coarse grain have made it a favorite for construction for decades. Port Deposit granite was cut from quarries north of its namesake town for almost two centuries.

The first record of a quarry was in 1789. There were several operating by the mid-1800s. The McClenahan quarry was located just south of the current location of the Port Deposit VFW Hall. The bridge quarry, just north of the McClenahan, was purchased by the Maryland Canal in 1829. There was also the Upper Quarry, the Frenchtown Quarry and the Keystone or Steele Quarry on Mount Arafat, the future site of Bainbridge. These quarries all had various life spans and multiple owners. The quarries' boom years were between the 1830s and the early years of the twentieth century. The granite was shipped around the country and was used in buildings

A view of one of the quarries once located on the north edge of Port Deposit. *Photo courtesy of the Historical Society of Cecil County.*

in Washington, D.C., the Naval Academy, the Boston Public Library, the Concord Point Lighthouse, various railroad bridges and tunnels, the Tomes School buildings and most of Port Deposit itself. The Port Deposit quarry operations effectively ended in the 1920s.

Vulcan Material's Havre de Grace Quarry operates on the western side of the river and can be seen from the I-95 Bridge. It's been in operation since 1905 and produces Port Deposit gneiss, a metamorphic rock that was once granite. The stone in the quarry is estimated to be 350 million years old. The operation covers 183 acres, is 250 feet deep and works on several levels. The gneiss is first blasted and then crushed into various sizes. Most of it is used for construction and road building. Rock is shipped on land, but six thousand tons a year are loaded onto barges at the quarry's private dock. These barges, pushed by large tugboats, go down the Chesapeake Bay, delivering the stone to Maryland's Eastern Shore. It's estimated that the quarry contains another one hundred years of stone.

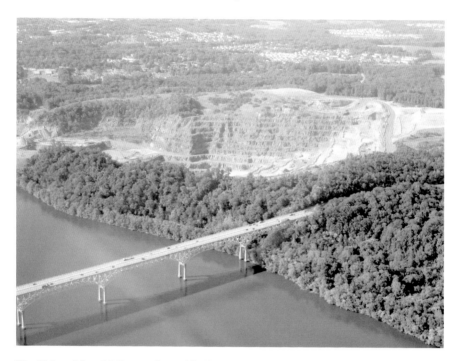

The Vulcan Material Quarry, located in Havre de Grace. It is still in operation and ships hundreds of tons of rock by truck and by barge. *Photo by Ben Longstaff, IAN Image Library, www.ian.umces.edu/imagelibrary.*

The three industries—quarries, logging and coal—helped the area become economically viable, but the Susquehanna River Valley still suffered. Coal may have had the most dramatic impact on the water quality of the Susquehanna River—you can see the acid on the surface—but logging has probably had the longer-term effect. Forests, such as those first seen by the early settlers, serve an important function as a buffer against runoff. The canopy not only shades the ground, but the leaves also filter and disperse rainwater as it falls. The soil at the ground level had been built up by falling leaves, dying trees and various insects. This layer further strains the water so it runs clear when it enters the stream.

The removal of the vast forests of the Susquehanna Valley allowed huge increases of rainwater to run into the river unimpeded. Floodwaters began reaching record levels in the 1860s. The flood of 1865 wiped out many of the canals. It was not unusual in the years following the Civil War to have waters rise thirty feet over normal, making the Susquehanna River one of the most dangerous flood rivers in this country. The impact of the clear-cutting was especially harsh when Hurricane Agnes devastated the

entire region in 1972. There have been a number of efforts to rebuild the natural forest barriers along the shorelines, but modern development often precludes the recovery.

You can always look back and find fault with the decisions made two and three hundred years ago. The concern in 1700 was economic survival, and the river, along with its resources, was the answer. There would be no Lower Susquehanna River Valley had there not been coal, lumber and stone to be shipped. We may suffer today because of the past, but at the same time the current residents are the beneficiaries of history.

ELECTRICITY AND WILDLIFE

There probably is no event more significant in the history of the Lower Susquehanna River Valley than the building of the Conowingo Dam nine miles above the river's mouth. The only one of several hydroelectric dams on the Susquehanna that is in Maryland, its effects have been cultural, economic and environmental. An entire town was relocated to accommodate it. The petroglyphs—writings on the rocks along the river left by Native Americans thousands of years ago—disappeared under the 150-billion-gallon lake behind the dam. It ended any dreams that the Susquehanna River would someday be navigable and ensured that Port Deposit's days as a major port were over. The river's flow was altered, and wildlife was irrevocably disturbed, especially the species of fish that used the river as a critical part of their migration and spawning. The Conowingo Dam may be an importance source of power in this energy-hungry age, but the electrons came at a high price.

The biggest impact can't be seen by the casual observer. Two hundred tons of silt lie behind the dam, and the volume grows every day. It's estimated that up to 15 percent of that sediment comes from products of the coal industry, an industry that has been effectively closed for more than fifty years. Hurricane Agnes scoured out the existing sediment when it hit the area with twelve inches of rain in 1972, but experts ask, "What's the plan today?" At some point, the space behind the dam will be full and something, as yet undefined, will have to be done. At the same time, the Conowingo Dam has become one of the prime breeding grounds for the American bald eagle, as well as 170 other species of birds, and each winter thousands of bird watchers migrate to the parking areas below the dam to observe these magnificent birds.

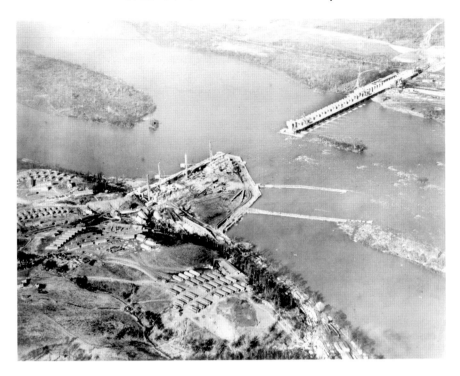

The Conowingo Dam under construction in 1926. The buildings along the near shoreline were the construction village, built to house the workers brought in to build the dam. *Photo courtesy of the Historical Society of Cecil County.*

The Conowingo opened in 1928, but the location has a long history. The rock writings and other signs indicate that it had been a site for a Native American village. The name itself is a Susquehannock word meaning "at the rapids." The falls immediately below are the farthest north that Captain John Smith reached in his exploration of the Chesapeake, and settlers soon established the small community of Conowingo. (It went under water when the dam was built and is now on the hill above the eastern approach to the dam.)

It was no surprise when the people of the Lower Susquehanna River Valley began petitioning for electricity that a hydroelectric dam at Conowingo was immediately proposed. The Maryland legislature authorized the Susquehanna Water Power and Paper Company of Harford County to acquire land for a dam. A small wing dam was constructed, but the project was sold in 1905 to a new company, the Susquehanna Power Company. Its plans were for a much larger dam. That organization ran into financial problems, delaying the project for two decades until Philadelphia Electric stepped in.

Tons of rock, a whole town and a railroad had to be moved to build the Conowingo Dam. *Photo courtesy of the Historical Society of Cecil County.*

Philadelphia Electric selected the Conowingo site despite the fact that a town and a railroad would need to be moved and there would have to be considerable reconfiguration of the landscape to accommodate the 105-foot-tall structure. The new dam would stretch 4,648 feet from shore to shore and have seven turbines (later expanded to eleven) to generate power. Philadelphia Electric awarded a design contract to Stone and Webster of Boston on January 23, 1925, but immediately ran into problems. Powerful political and business interests in Baltimore were adverse to a Pennsylvania company earning revenues from a project in Maryland. Negotiations went back and forth until the Maryland legislature announced an agreement. The Conowingo Dam could not run its power transmission southward for a period of fifty years.

The story of the Conowingo Dam is also a story of the American shad. The author John McPhee called the shad the "founding fish" in a book of the same name. In it he discusses the importance of the shad to the American economy. Legend has it that the spring shad migration on the Schuylkill River saved the lives of George Washington's frozen, starving troops at Valley Forge. Shad were once the most plentiful fish in the eastern half of the United States, found in rivers from Maine to Florida. They were the most commercially successful catch in the 1800s. The American shad had long been a staple of the Chesapeake Bay. The first treaty with the

102

Where the River Meets the Bay

Native Americans, negotiated in 1652, contained a clause that protected their shad fishing grounds. The biggest economic blow struck by the British in the War of 1812 was their plundering of the barrels of shad stored in the Lower Susquehanna River Valley. The total harvest in 1897 was more than twenty-nine million pounds. Eight million of those pounds came from the Chesapeake Bay and its tributaries.

The total catch from the Chesapeake Bay dropped to half a million pounds by 1946, but reckless harvests were not the only cause of the shad's decline. Shad are anadromous. They spawn in fresh water, swim to sea—where they grow to adulthood—and then return to their birthplace to create the next generation. The homing instinct of the shad is so strong that they have been known to throw themselves against any obstacle in their way. They were about to run into the largest obstacle of all. One of the prime spawning grounds was the Susquehanna River above the proposed Conowingo Dam. Though the fishermen of the Lower Susquehanna River Valley made their concerns known about the dam's impact on shad, their power as environmentalists in the 1920s was far less than what they would have had in the 1980s. People wanted lights instead of fish.

Philadelphia Electric had other problems. It had announced that the Arundel Corporation was to be awarded the $20 million contract to construct to the dam. The Arundel Corporation was owned by Frank First, a Democratic Party heavyweight and a close friend of the governor, Albert Ritchie. People remembered a controversial deal twenty years before when a relative of the governor at the time was one of seven stockholders who were able to buy and operate the old railroad bridge in Havre de Grace. They made a fortune off the toll revenue, and they also received a large amount of money when the state later bought the bridge. This looked to be the same type of back-office deal.

After a short but intense fight, First and his Arundel Corporation prevailed. The company began work on the Conowingo Dam in 1926, a hydroelectric project second in size only to the effort at Niagara Falls. Approximately 3,800 workers, who lived in a company town along the west side of the river, were brought in to build the structure, but the dam's planners missed one key concept that they could have learned from anyone who lived and worked along the Susquehanna: you may be able to dam the river, but you can't control the amount of water in the river itself.

Philadelphia Electric would soon learn that during some seasons, and in some years, there was not enough water to turn the turbines, and then at other times, the water volume was so great that all fifty gates had to be opened. This interruption in the natural flow of the river caused many problems

below the dam. Port Deposit, which had lost its status as a port because of the dam, hoped that its construction would control the devastating floods, but the town still went under water when the dam opened multiple gates. At other times, the already shallow river was reduced to rocks and mud when the dam closed the gates in hopes of capturing enough water to generate electricity. There were periods around the time of World War II when the gates were closed more than opened.

The dam had been granted a fifty-year operating license with no requirements for minimum or maximum flows. Millions of shad, and other spawning fish, would gather below the dam. If the flow was shut off, there was no replenishment of the oxygen, and the water temperature would rise to dangerous levels. The river became choked with dead and rotting fish, creating a stench that lasted for months. Commercial interests had pulled seven million pounds out of the Chesapeake Bay as late as 1889, but the shad population was declining at an increasing rate. Scientists estimated that only twenty thousand shad had returned to the Bay's tributaries in 1979. The State of Maryland became increasingly concerned about the future of fish, resulting in a total ban on shad fishing in 1980.

Philadelphia Electric denied that the dam and the water flow had any effect on the shad population, claiming that it was due to overfishing and pollution, a statement that was not wrong but rather incomplete. When the water flow was cut off in 1971, the outrage was such that it agreed to keep a minimum water flow of five thousand cubic feet or 37,400 gallons per second. That figure is about 13 percent of the average flow of the river in its natural state, and critics were not satisfied. The next year, Hurricane Agnes hit, producing a one-hundred-year volume of rain that flooded most of the northeastern United States. The dam opened all fifty gates, sending billions of gallons of water downstream and into the Chesapeake Bay. A fifty-year supply of sludge went with the water, wiping out submerged vegetation across the upper Chesapeake Bay.

Scientists began studies of the American shad in the early 1960s to determine the viability of building passageways around dams not only on the Susquehanna, but also on the Merrimack and the Columbia. They concluded that for $5 million a lift could be constructed that would allow the fish to rise over the dam. The study neglected to say who would pay for it. Philadelphia Electric was not anxious to spend the money but, in 1964, agreed along with three other utilities to invest in a project that imported shad eggs to be planted above the dam. This study concluded in 1968 that the water quality would support the shad if a way could be found to get them there.

Reluctantly, and with a considerable push by the governor of Pennsylvania, Philadelphia Electric agreed in 1970 to build a $500,000 fish ladder. Built on the west side of the river, it opened in 1972 and, for the next nine years, lifted an average of 105 shad per year. Philadelphia Electric claimed that the results did not justify the amount of money spent. A senior official of the company said in the late 1970s, "There are no shad, and those that believe that there are, or ever will be again, are hopelessly naive."

Naive they might be, but the shad advocates were not going down without a fight, and they chose the license renewal process of the late 1970s to make a stand. One issue they had was that the lift was on the wrong side of the river. The shad congregated on the river's east side, where the flow, even in slow times, was stronger. The water had more oxygen. The dam's operators balked at a further investment in what they labeled as a hopeless effort.

The fight was on and would wind its way through various state and federal courts and agencies until 1986. A law judge for the Federal Energy Regulatory Commission ruled that "fish passages were a cost of doing business on a river containing anadromous fish populations." Five years later, Philadelphia Electric opened a new, $12.5 million ladder on the east side of the dam. Between it and the older lift, three million shad can rise above the dam in a season. The company also agreed to keep enough constant flow through the dam to ensure the survival of the shad. The moratorium on shad harvesting remains in place in Maryland, though catch-and-release fishing is permissible.

The dam, now owned by Exelon Power Corporation, produces 548 megawatts of power, adding 1.6 billion kilowatt hours to the U.S. power grid. It's one of the prime areas for viewing the American bald eagle. The Conowingo Dam area is attractive to them because of the readily available supply of fish, some of which come through precut by the dam's turbines. Blue herons, osprey and a dozen smaller species of birds are spotted along the shoreline and on the rocks below the dam. Trails, part of the Susquehanna Greenway, run along the west side of the river from Havre de Grace and allow a hiker to go from the river's mouth to Harrisburg, Pennsylvania. The view downriver from the dam is also undeniably spectacular.

The dam's operating license will be up for renewal in 2014, and another fight looms, this time over the American eel. The eel are catadromous, meaning that they breed in the salt water of the Sargasso Sea but migrate to the fresh water of East Coast rivers, including the Susquehanna. They stay until they reach adulthood and then make a return trip to their spawning grounds.

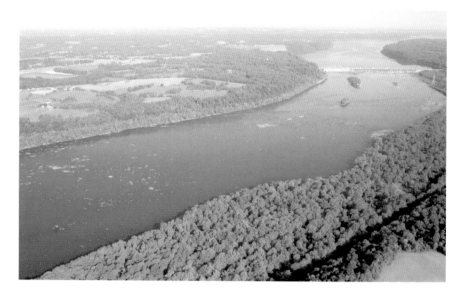

An aerial view shows the Conowingo Dam and the river south of it today. *Photo by Jane Thomas, IAN Image Library, www.ian.umces.edu/imagelibrary.*

Recent studies have shown that the American eel is far more important than previously known. Larger species, such as rockfish, depend on the eels for food. The eel, like the oyster, filters the water and is an important component of the Chesapeake Bay ecosystem. The problem is that the eel's migratory patterns are so completely different than the shad's that a separate lift would have to be constructed. The dam's turbines are also a greater danger to the eel than the shad. The shad going downriver are immature small fries that easily slip through. The eels are adults that get chewed to pieces when they try to swim downriver.

Environmentalists want to make the future of the American eel part of the license-approval process. On top of that issue, many people are concerned about the sediment building behind the dam. A USGA study says that the capacity to hold sediment behind the dam would be filled within twenty years. That's if there is not a repeat of a storm such as Hurricane Agnes. The Conowingo Dam is a fixture of the Lower Susquehanna River Valley landscape that residents have long since accepted. Sometimes it's been a good citizen and at other times a bad one, but it's a critical part of the history, and the future, of the region.

Wooden Ducks and Slippery Fish

The Chesapeake Bay in the early 1600s was a virtual cornucopia of wildlife and flora. Captain John Smith and his crew were constantly surprised at the abundance as they made their way north from Virginia. His journal notes two of the most prevalent fish and waterfowl. He wrote, "Abundance of fish lying so thick with their heads above water…we attempted to catch them in frying pans." He later commented, "And the winter approaching, the rivers became so covered with swans, geese, ducks and cranes that we daily feasted…fish, fowl, and divers sorts of wild beasts as fat as we could eat them." From Smith's words and observations grew two of the major industries of the Lower Susquehanna River Valley—fishing and duck hunting. The second resulted in the creation of one of our most original folk arts, decoy carving.

Evidence has been found that both Perry Point and Garrett Island were fishing and hunting camps for several groups of Native Americans. The last group, the Susquehannocks, is recognized as a primarily hunting and fishing culture. They used the river to move between the fertile land of what is now central Pennsylvania, where they planted crops in spring, and the river's mouth, where they spent the summers fishing and the fall hunting, returning north before winter to harvest their farm crops. The first treaty between the Susquehannocks and the English settlers in 1652 partially existed because the natives wanted to protect their fishing grounds at the mouth of the Susquehanna River.

The early English settlers noticed that the Susquehannocks had developed a number of tools to increase their fishing productivity. They wove small tree branches into structures called weirs that they would stake in a V-shaped pattern stretched between the shores of the Susquehanna River. The migrating fish, primarily shad and herring, would be trapped in the V as they

moved upstream. The Indians would simply wade out and remove them. The Susquehannocks had perfected the technique of using fire to reduce hardwoods to charcoal. They would then smoke the shad and herring over the burning coals. The process would take several days, and when they were done, the fish could be packed for eating in the barren months of winter. Settlers soon adopted both the use of the weirs and the smoking of fish to preserve them, adding their own English modifications such using oak barrels to pack the smoked fish for shipping inland.

The Susquehannocks were also aware of the rich grasses that grew across the Susquehanna Flats, the thirty-six-square-mile delta formed by sediments brought down the river. The Flats begin one hundred yards off of Perry Point and stretch southward for five miles and east for three miles. The average depth is two feet, allowing sunlight to reach the bottom. The combination is perfect for the production of what are now known as submerged aquatic vegetation (SAV). The wild celery alone was enough to sustain the legendary population of canvasbacks, mallards, red backs, broadbills, teel, greasers and blue wing ducks that once visited the Flats. A seventeenth-century writer reported that one flock of ducks was a mile wide and seven miles long.

The Native Americans would take their canoes to the edge of the shallow water and place crudely carved decoys across the water. They would then lie low in the water with only their heads above the surface. The ducks would circle and land, unaware of the danger that faced them. The Susquehannocks would rise up and use their bows and arrows to bring down the unsuspecting waterfowl. This meat was also smoked for later consumption. The English soon adopted the methods of the Susquehannocks, but they would anchor along the edge of the Flats in shallow-bottom boats and use their muskets to shoot the ducks.

Fishing became, along with fur trading, the earliest real industry in the Lower Susquehanna River Valley. By the Revolutionary War, hundreds of barrels of shad and herring were being shipped to the major cities of the colonies. Sixteen thousand barrels of smoked shad and $18,000 of fresh fish were produced in Cecil County in 1807. Fishing had become a large enough business that the State of Maryland passed one of the first environmental laws in 1810, forcing the industry to clean the shorelines of the fish waste at the end of the season. Thomas Stump, fishing near Spesutie Island, reported catching fifteen million shad in one day in 1827, enough to fill one hundred wagons.

Nets called seines were introduced in the 1820s, dramatically increasing productivity. Commercial fishing companies would employ hundreds of temporary workers to stretch the seines across entire rivers, trapping shad,

herring, perch, sunfish, catfish, rockfish, carp and pike. Each of these was sold commercially as food or fertilizer, but the impact of the catches could be felt through declining fish populations as early as the 1830s.

The men of the Lower Susquehanna River Valley fished in the summer and did gunning, or water fowling, in the fall and winter. By the early 1800s, they had taken the basic concepts of decoys used by the Susquehannocks and developed sophisticated representations of the various ducks and geese that fed on the Susquehanna Flats. Using the white pine logs that escaped from the upstream logging booms, carvers began to specialize. One would be the expert on creating canvasbacks; another would concentrate on redheads or mallards.

The sink box—a floating, coffinlike platform—came into widespread use. The use of the sink box was outlawed in 1935, but in the 1800s as many as fifty sink boxes were hauled to the Flats from Havre de Grace alone. Guns became more sophisticated. The flintlocks and wheel locks of the first settlers were replaced by shotguns. The early versions had single barrels. The shooter made up for the gun's lack of accuracy by firing a heavy load of ten-gauge buckshot that dispersed over a wide area. Later guns had multiple barrels. The famous Chesapeake Bay punt guns featured a single-trigger mechanism that fired as many as twenty separate loads, though many experts dispute the effectiveness of the design. The development of the automatic shotgun, one that could fire a dozen shells in succession, did more for hunters than the sheer volume of the punt guns. The improvement in the rifling inside of the barrels meant that the gunners could hit what they aimed at.

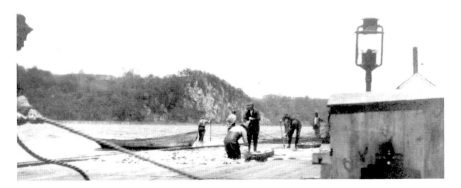

The fishing industry used floats, basically water-based fish-possessing factories, to exploit the resources of the river. This float was located near Mount Arafat. *Photo courtesy of the Historical Society of Cecil County.*

The return of spring meant that the guns were put away and the seines came out. Asabel Baily, a Havre de Grace–based fisherman, invented the float, basically a fish factory on the water, in the 1820s. Dozens of men, housed in temporary facilities, worked on a float. Some would catch the fish with the seines, while others cured and salted the fish. Smaller boats would haul the barrels to shore. What could not be processed in the floats was brought to one of the many fish houses that opened in Havre de Grace, Lapidum and Perryville and were built on the islands of the Susquehanna. The largest fishing company was Spencer, Silver and Company of Havre de Grace. It ran three of the biggest floats and three packinghouses onshore, including those on Garrett Island. It was in business for more than one hundred years, shipping as many as 100,000 barrels of shad annually in the early 1900s. The family became quite wealthy—their mansion has been restored as a bed-and-breakfast in Havre de Grace—but the fish population declined so severely in the first quarter of the twentieth century that commercial fishing came to an end. The final blow was the opening of the Conowingo Dam in 1928. The shad and herring could no longer reach their spawning grounds.

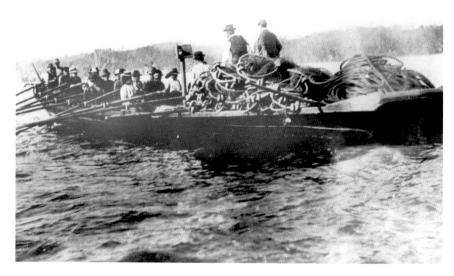

Boats were also used in the fishing industry. Shad and herring were prime targets of both the floats and the boats. *Photo courtesy of the Historical Society of Cecil County.*

Gunning was also changing. By 1880, the Susquehanna Flats had become the most famous duck hunting spot in the world. The business model shifted from hunting for your own needs to guiding wealthy "sports" that came to the area. Well-appointed hotels, such as the Bayou, built along Havre de Grace's shoreline overlooking the Susquehanna Flats, opened to handle the gunners. Sink boxes were anchored around the Flats. The guides would place their clients in the boxes and set three to four hundred decoys in two lines. One line would be thirty-five to forty yards to the front of the sink box, and the other off to the right or left. The effectiveness of the approach was impressive. One man reported killing 509 ducks in a single day.

Gunning clubs were built to accommodate the rich and famous that came for the hunting. Spesutie Island was bought in 1899 by a group of New York investors, including members of the Auchincloss, Morgan and Post families. They built the Spesutie Island Rod and Gun Club on the six hundred acres along Sandy Point. For twenty years it was the most famous sporting club in the United States and counted senators and presidents as visitors. The wealthy hunters used luxury yachts—such as the *Reckless*, a sixty-two-foot sloop based in Havre de Grace—as gunning platforms. These floating

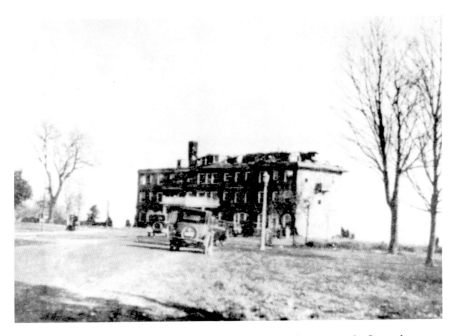

The Bayou Hotel was built to house wealthy duck hunters who came to the Susquehanna River Valley each season. This image was taken after a devastating fire destroyed most of the building's interior in the 1920s. *Photo courtesy of the Historical Society of Harford County, Inc.*

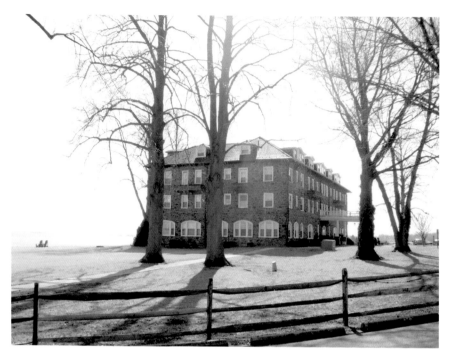

The Bayou Hotel today is home to offices and condominiums. *Photo courtesy of the author.*

clubhouses featured bars, gourmet food and gambling. If the sport felt like shooting a duck, all he had to do was go out on deck.

Like commercial fishing, the success of gunning was its ultimate downfall. The population of ducks and geese was severely reduced by the indiscriminate killing. Maryland began introducing regulations involving waterfowl hunting as early as 1833, but in 1935 it outlawed the use of sink boxes. The Spesutie Island Rod and Gun Club was incorporated into the new Aberdeen Proving Ground. The Bayou Hotel closed, a victim of the Great Depression and a devastating fire. A severe storm blasted through the region in August 1950, destroying the wild celery and other grasses that had grown on the Flats for centuries. The lack of food forced the remaining waterfowl to seek other grounds.

Two things occurred in the years immediately following the end of World War II that revitalized these industries. Rockfish, known everywhere else as striped bass or stripers, became the number one choice of sport fishing people; and decoys, which had lost their utilitarian value with the decline of water fowling, were discovered as an art form.

Where the River Meets the Bay

Rockfish had come to the edge of the Susquehanna Flats for centuries to feed and breed. They had been caught as food since the time of the Native Americans, but the expansion of leisure activities in the 1950s meant that people would pay for the privilege of hooking one. Fishing guides became a growth industry, and stripers were the money fish. Boat manufacturers began building inexpensive models that the average family could purchase. They would spend their Saturday mornings casting for rockfish and largemouth bass. Marinas with boat ramps were built in Havre de Grace and Perryville.

People also came looking for the best examples of carved duck decoys. Carvers such as Daddy Holly, R. Madison Mitchell, Robert McGraw, Paul Gibson, members of the Jobes family and Charlie Joiner became famous. Collectors would pay top prices for their best work. A swan decoy made by Daddy Holly sold at a 1987 auction for $66,000. Havre de Grace recognized the value of its heritage. The Duck Decoy Museum, built on top of the Bayou Hotel's indoor swimming pool, opened in 1982. Twenty-five thousand people visit the museum each year.

The success of sport fishing for rockfish was once again the beginning of its collapse. Overfishing and pollution had decimated their numbers. Maryland was concerned that the species that it had named the state fish in 1965 would disappear. It took the extraordinary step of placing a moratorium on the catching of rockfish in 1985. Experts point to this as a model for environmental law because it worked. The rockfish recovered enough that by 1989 limited fishing was once again allowed.

Today, the regulations concerning both water fowling and rockfish are complex and difficult to understand, but both activities remain staples of the area. Hundreds of boats come to the edge of the Flats each spring to go for rockfish. Dozens more participate in the largemouth bass tournaments held every summer weekend. Bird watchers come to spot the ducks and geese that are slowly returning to the Flats. (Hurricane Agnes once again destroyed the underwater grasses that had begun to recover from the 1950 storm.) The Duck Decoy Festival held each spring brings thousands of fans of wildlife carvings and paintings. Hunting and fishing have come full circle. They are once again important industries of the Lower Susquehanna River Valley.

HORSE SENSE

It seems odd that horse racing and breeding would count as one of the main industries in a region dominated by the water, but the Lower Susquehanna River Valley has a long history as the home to thoroughbred horses, tracing back to the 1600s when the wealthier English settlers came to the New World and brought their quarter horses with them. This trend accelerated during the reign of Oliver Cromwell, who confiscated the king's stables and began breeding cavalry horses instead of thoroughbreds. English racing horses returned after his downfall, but much of the best breeding stock had been brought to the colonies.

The true moment when Maryland horse racing came into its own was in 1730, when Bulle Rock, considered by many the finest horse of the times and the father to all American thoroughbreds, was brought to this country. (The championship golf course and upscale housing development built on a 235-acre former horse farm outside of Havre de Grace is named after Bulle Rock.) Other important horses, Messenger and Diomed, were brought to Maryland around the time of the American Revolution.

The industry went into retreat during the Revolutionary War but resumed after the British surrender. Then, as now, there were people who were adamant that horse racing was a tool of the devil. Southerners claimed that the sport was an important element in their culture while those in the North felt that it should be banned. Neither side ever claimed a clear victory. This continuous battle reached the Lower Susquehanna River Valley in 1912 when John J. Mahan, a political boss from Baltimore, and Timothy O'Leary purchased 132 acres of Old Bay Farm located just outside of Havre de Grace. They announced their intention to use the land that ran along the Chesapeake Bay as the site for a major horse track. The governor of Maryland immediately announced his opposition.

Where the River Meets the Bay

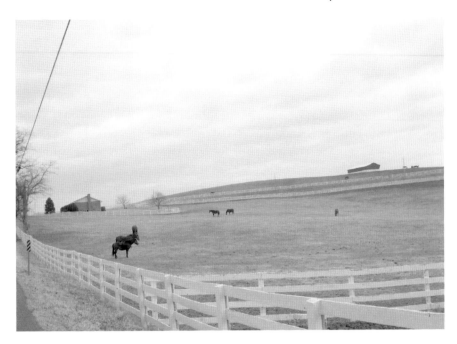

A view of a Harford County thoroughbred farm. Both Cecil and Harford Counties have long, rich traditions of breeding champion horses. *Photo courtesy of the author.*

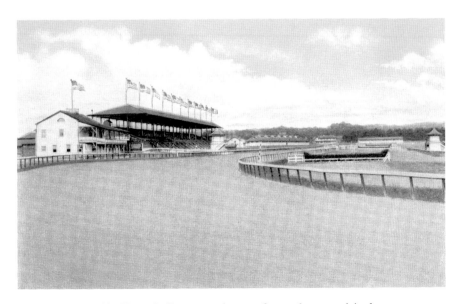

The Graw, located in Havre de Grace, was the most famous horse track in the country from its opening in 1912 until it closed in 1950. *Photo courtesy of the Historical Society of Harford County, Inc.*

Mahan and O'Leary were acting as a front for a longtime New York–based racing expert, Edward J. Burke. He was named president and general manager and was the major stockholder of the proposed track. Burke had fought the political battles over racing before and defeated both the governor's objections, as well as another contender for the license. Henry B. Wolf, a wealthy criminal lawyer from Baltimore, had purchased the western 235 acres of Old Bay Farm, intending for his partnership to be the winner in the fight over the license. The shrewdness of Burke prevailed and Wolf lost his bid. He would eventually end up disbarred and imprisoned for hiding a bank robber in his Baltimore home. The Burke investors bought his section of the Old Bay Farm.

The Havre de Grace Racetrack, operated by the Harford Agricultural and Breeders Association, officially opened for racing on August 24, 1912. The first winner was Insurance Man. The track was an immediate success. There were thirteen days of racing in the fall and another thirteen scheduled for each spring. The quality of the racing attracted wealthy bettors from New York, Philadelphia and Baltimore. Many spectators came for the view of the Chesapeake Bay from the grandstands. On the grounds there was a casino with roulette and, in the early years, a steeplechase course in the infield. Both the B&O and the Pennsylvania Railroad began running special trains to the races. In the early 1930s, a round-trip ticket from New York was $1.30.

The 7,700 residents of Havre de Grace prospered. There were often as many as eight hundred horses in town for the season, far more than the stables at the track could hold. Barns opened around town for the extra horses, and guesthouses and hotels sprung up for the human visitors. The track received a major boost in 1920, when what may be the most famous racehorse in history, Man o'War, won the Potomac Plate. Other notable horses such as Citation, War Admiral and Seabiscuit also paid visits to the racetrack.

A number of the horses were killed in a 1929 barn fire, but track attendance continued to grow even as the Great Depression approached. The 1940s saw another political fight when off-track betting was proposed as a method of eliminating illegal bookmaking. The proposal was defeated, but the racing schedule was affected with the onset of World War II and the course was closed in 1943 for the duration of the war.

The racetrack reopened in 1946, but Edward Burke by then was also named president of Delaware Park in Wilmington. Two jobs proved to be too much. Burke left Havre de Grace as the track reopened. An additional problem was the new Garden State track in New Jersey that was closer to

the big bettors from New York and Philadelphia. That track began to draw visitors away from Havre de Grace, and attendance dropped.

The track was the scene of a historical moment in 1948 when the Triple Crown winner, Citation, was defeated by Sassy. It was an upset of major proportions that temporarily renewed interest in the track, but by 1950 the owners were forced to sell for $1.8 million to the developers of Pimlico and Laurel Racetracks. The Havre de Grace racing dates were transferred to those two tracks.

The last race, won by Charlight, was run on April 26, 1950, with 8,200 people in attendance. The track closed, and the grandstands were torn down. The valuable land was abandoned until it was proposed that the Maryland National Guard, which was closing a base in Western Maryland, build a facility there. It was another political battle since the property was considered by many to be a poor location, but those in favor won. The state paid $500,000 for the land, and the base was opened in 1951 as a temporary location. It's still a National Guard Armory today with no apparent plans to close it. The old track received one more moment of fame in the 1970s when a scene in the movie *The Sting* mentioned the Graw, the track's longtime and much-despised nickname.

The horse racing tradition of the Lower Susquehanna River Valley continues. Horse farms dot the hills on both sides of the river, and the five-thousand-acre Fair Hill Natural Resources Area, a former DuPont estate in the northeast corner of Cecil County, is the home of two equestrian organizations and the annual Fair Hill Races. There is talk every year of constructing a museum celebrating Maryland's thoroughbred history on the National Guard site, but it never goes beyond the discussion phase. Most people don't realize the history and importance of thoroughbred racing to the region.

TOUCHING HISTORY

One unique factor of the Lower Susquehanna River Valley is the number of excellent museums around the area. There are five in Havre de Grace alone, with more in Port Deposit and Perryville. There are also a number of historic buildings, such as the O'Neill house and the homes at Rock Run Mills, that are open for viewing. A visitor would receive a significant return on the time invested by exploring all of these, but the region is unique in another way. There are dozens of opportunities to experience history in the moment rather than in a building.

We often think of history in the abstract, but for me, at least, it comes alive when you can stand at the exact spot where an event happened. Many years ago, I went to a bank in Italy to transact business. The cornerstone caught my eye as I went in. The bank had been in this same building since 1490, two years before Columbus sailed to the New World. I may have stood in the same lobby where he obtained the finances for the trip, or at least cashed a check. Columbus was no longer a mythical figure; he was a real person. The Lower Susquehanna River Valley abounds with these situations.

Most of my days begin the same way. I rise, drink a quick cup of coffee while I glance at the headlines of the newspaper and check the weather forecast on the television. Then it's time for my morning walk, which takes me along the waterfront of Havre de Grace. I reach the halfway point at the Concord Point Lighthouse. That structure is historic in its own right, but the full impact of the region's history comes when I remember that I am standing at the exact spot where John O'Neill made his ill-fated attempt to defend the town from the invading British. When you're looking out on the stretch of water where the British were anchored, it's easy to imagine the terror that struck the townspeople when they awoke on May 13 and found five warships off the point.

Where the River Meets the Bay

Continuing on, my walk takes me past the place where President Bill Clinton stood and announced the opening of Earth Day. There are two Havre de Grace museums along the wooden promenade, three if the skipjack *Martha Lewis* is in port. Ahead on the bluff is the original Bayou Hotel. It's not a museum but is nevertheless a historic landmark at which people still live. Living history is something that you can touch and something that surrounds us virtually every day of our lives.

The wide, flat and lightly traveled streets of the Veterans Hospital in Perryville make an excellent place to ride bikes. You realize as you peddle around the property that people have lived on this point for more than ten thousand years. The 250-year-old Stump Mansion, where aggressive Union soldiers used the woodwork for sword practice during the Civil War, is a relative newcomer to the property.

The original Rodgers Tavern sits right outside the entrance to the Perry Point Veterans Hospital and is worthy of a stop, but for me it's not the building, or the fact that George Washington took a meal there, that's interesting. It's the fact that you can walk down to the river's edge and imagine that you're standing there as the lone ferryboat hauled Washington's men of the Continental army across the Susquehanna River, ten soldiers at a time. He becomes more than a face on a dollar bill when you imagine him sipping a beer at the tavern as he shakes his head in frustration at the time wasted with the ferry. There's a war to be won, and he can't get there quickly enough. If you look to the right, you can see the ultimate solution to his problem: the piers from the original 1866 railroad bridge.

My family and I respect the nature sanctuary of Garrett Island and never attempt to land on it, but when we look down on it from the Hatem Bridge or up to it as we paddle by in our kayak, it's easy to imagine that we're looking at the location where John Smith spent the night four hundred years ago. Today, the island looks very much like it would have in 1608.

The Lower Susquehanna River Valley has dozens of examples of living history. The historical buildings are often not places that are open on weekends for visitors, but rather they are real homes with current residents. There is an excellent museum, the Susquehanna Lockhouse Museum, dedicated to the canals, but you don't have to go there to see the remains of the canal system. You can hike along the old canals by following the trails of the Susquehanna Greenway.

Not every place is accessible. Bainbridge is decaying behind barbed wire and chain-link fences, but this is the exception rather than the rule. Americans tended to tear down, rebuild and then lament the loss later. That

explains the popularity of places such as Williamsburg. There is value in visiting such well-executed venues, but for me the opportunity to touch and feel history brings life to what are often static words or exhibits. The Lower Susquehanna River Valley is blessed in many ways—with its beauty, its history and the fact that the beauty and history are still there for daily viewing.

THE RIVER IN THE
TWENTY-FIRST CENTURY

The Susquehanna River is unique in many ways. Though it has been an economic workhorse for four hundred years of European settlements, it has never seen the large cities and concentrated, heavy industry that most American rivers have experienced. The Susquehanna River has suffered from even its limited use. The Lower Susquehanna River Valley, located at the literal end of the line, has suffered more than other places.

Though the cities are small in comparison to Pittsburgh on the Ohio or St. Louis on the Mississippi, the metropolitan areas of Harrisburg, Wilkes-Barre/Scranton and Binghamton are large enough to have produced significant sewage over the years. Industry, while more widespread than other locations, has had an effect. A large steel plant operated for many years just south of Harrisburg. There have been dozens of tanneries, slaughterhouses and chemical plants that have dumped their waste into the Susquehanna River. These are in addition to the two major industries, coal and lumber, discussed earlier in this book.

The harvesting of trees upstream of the Lower Susquehanna River Valley has removed the natural filtering processes so vital to the environment. These forested buffers have been replaced by farms and suburban lawns. Fertilizers run freely into the Susquehanna River. Sediment flows off construction sites with poor or nonexistent containment fences. These runoffs produce algae blooms in Havre de Grace that block the sunlight so necessary to the growth of the submerged aquatic vegetation on the Susquehanna Flats. Fish, shellfish and waterfowl suffer.

We have begun to recognize as a nation that high-quality water is not a luxury but rather a necessity. The Clean Water Act, originally enacted in 1972, was a major first step. The act called for zero pollutant discharge into navigable rivers by 1985. We have fallen far short of that goal, but there has

been considerable progress. Sewage treatment techniques and facilities have improved, and the volume of industrial waste products being released into our rivers has been cut dramatically, but the EPA reports that there is still considerable progress to be made. Water pollution from storm water runoff and agricultural discharge remains a major problem. The Susquehanna River has benefited from the changes mandated by the Clean Water Act, but like most waterways, it is a victim of its past and its own environment. The shoreline of the 440-mile Susquehanna may be mostly rural in nature, but that means that more homes and businesses are on septic systems instead of public sewers. The farms along the way also contribute to the runoff.

Another indication that Americans are concerned about their rivers is the growth of the grass-roots organization the Waterkeeper Alliance. In 1966, a group of concerned citizens, including many celebrities, became concerned about the poor water quality of the Hudson River. They held festivals, meetings and protests to bring national awareness to the problem. A "riverkeeper" for the Hudson was appointed in 1983, the first such post in the United States. The person in this position would target, and pursue legal action against, polluters. The program spread, and soon there were "riverkeepers" across the country. It was recognized that an umbrella organization was needed to provide support for these grass-roots efforts. The Waterkeeper Alliance was born in 1999. Today, there are 183 "riverkeepers" on six continents. One river with a keeper is the Lower Susquehanna River.

Michael Helfrich, a York, Pennsylvania native, has the responsibility of watching over 9,215 square miles of the Susquehanna from Sunbury, Pennsylvania, to the mouth of the river at Havre de Grace. He's had the role since 2005 but has studied the river and its tributaries since childhood. He lists numerous problems that still exist with the water quality but suggests three things that anyone can do to contribute to restoring the Susquehanna River. The first is to be a good steward. It takes more than one person to care for and solve the complex problems faced by the Susquehanna and other rivers.

The second is to look for solutions to problems that make sense both in economic and environmental terms. The most successful of these win/win situations is the striped bass, or rockfish, as they are known locally. The moratorium introduced by the State of Maryland was a blow to charter captains and commercial fishing operations, but in a few short years, the fish had shown remarkable recovery. The industry today produces more revenue than ever before. As evidence, count the number of boats fishing for the coveted rocks along the edge of the Susquehanna Flats each spring.

Where the River Meets the Bay

The last and easiest thing to do is to simply plant trees. There are no better barriers to water pollution than trees filtering the water before it enters the stream. These need not be restricted to the shorelines. The Susquehanna River benefits from any tree planted within its watershed.

No history of the Lower Susquehanna River Valley would be complete without a review of both the good and bad that has resulted from that history. The region's growth and economic viability can be traced to the use of the river, but we need to understand the impact that this has on our future. The Lower Susquehanna River Valley remains one of the most beautiful spots in the entire Chesapeake Bay area, but it will take much work on the part of everyone if it is to remain that way.

Bibliography

Bates, Bill. *Images of America: Aberdeen Proving Ground.* Charleston, SC: Arcadia Publishing, 2007.

Blungent, Pamela James, comp. and ed. *At the Head of the Bay: A Cultural and Architectural History.* Rising Sun, MD: Cecil County Historical Trust, 1996.

Diggins, Milt. *Images of America: Cecil County.* Charleston, SC: Arcadia Publishing, 2008.

Healey, David. *1812: Rediscovering Chesapeake Bay's Forgotten War.* N.p.: Bella Rosa Books, 2005.

Jay, Peter A., ed. *Havre de Grace: An Informal History.* N.p.: Susquehanna Publishing Company, 1986.

Johnston, George. *History of Cecil County.* Baltimore, MD: Genealogical Publishing Company, 1989.

MacKay, Bryan. *Hiking, Cycling, and Canoeing in Maryland: A Family Guide.* Baltimore, MD: Johns Hopkins University Press, 2008.

Miller, Alice. *Cecil County Maryland: A Study in Local History.* Port Deposit, MD: Port Deposit Heritage Inc., 1949.

Mills, Eric. *The Chesapeake Bay and the Civil War.* Queenstown, MD: Tidewater Publishing, 1996.

Quesenbery, Erika. *Images of America: United States Naval Training Center, Bainbridge.* On behalf of the Bainbridge Historical Association. Charleston, SC: Arcadia Publishing, 2007.

Stranahan, Susan Q. *Susquehanna: River of Dreams.* Baltimore, MD: Johns Hopkins University Press, 1993.

Wennersten, John R. *The Chesapeake: An Environmental Biography.* Baltimore: Maryland Historical Society, 2001.

———. *Maryland's Eastern Shore: A Journey in Time and Place.* Queenstown, MD: Tidewater Publishing, 1992.

About the Author

Dave Berry has lived within the Chesapeake Bay watershed for the last twenty-six years, most of the time in Lancaster, Pennsylvania, and more recently on the bay in Havre de Grace, Maryland. He holds a one-hundred-ton U.S. Coast Guard OUPV license and is an ASA-certified sailing instructor. He both teaches and does charter work with Baysail in Havre de Grace.

Dave is also a writer. His column "Tacking About" appears in the bay-area publication the *Mariner*. He has published articles in *Sailing Magazine* and the *Baltimore Sun* and is author of the book *Maryland Skipjacks*. He spends

The author leans against the cannon used by John O'Neil against the British in May 1813. It is mounted near the base of the Concord Point Lighthouse. *Photo courtesy of the author.*

his free time doing volunteer work on the skipjack *Martha Lewis* and with the Chesapeake Bay Foundation. Prior to his current life on and near the water, he spent twenty-five years in a variety of sales and executive positions in the telecommunications industry.

When not sailing for work, he and his wife sail their own boat. They have two children, a son Jason in Dover, Delaware, and daughter Julie in Wellington, New Zealand.

Visit us at
www.historypress.net